East Kent at War

IN OLD PHOTOGRAPHS

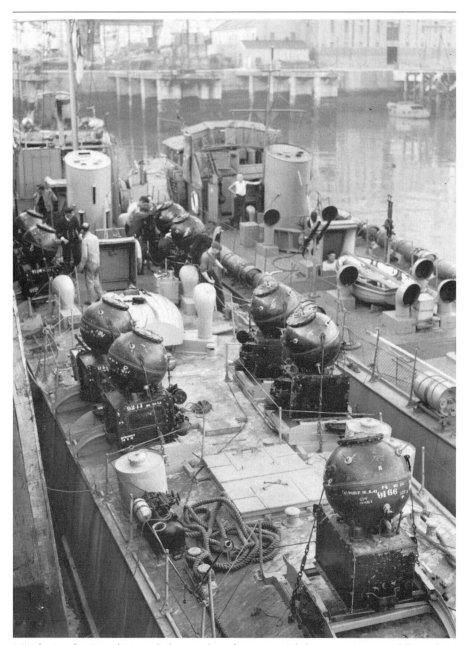

Minelaying by Royal Navy light naval craft was a nightly occupation, and here their crews busy themselves in maintenance and refuelling during the day, while tied-up in the Camber at Eastern Docks, Dover. The buildings of the former Admiralty Dockyard (abandoned in 1925) can be seen in the background; this whole area has been filled in to provide parking for freight vehicles carried on cross-Channel ferries.

East Kent at War

IN OLD PHOTOGRAPHS

DAVID COLLYER

Alan Sutton Publishing Limited
Phoenix Mill · Far Thrupp · Stroud
Gloucestershire

First Published 1994

Cover picture:
On the look-out for dive-bombers, this
member of the Royal West Kent division has
his Bren gun ready to engage enemy aircraft in
his exposed gun pit somewhere between Hythe
and Dungeness.

British Library Cataloguing in Publication Data.
A catalogue record for this book is available from
the British Library.

ISBN 0 7509 0774 6

Typeset in 9/10 Sabon.
Typesetting and origination by
Alan Sutton Publishing Limited.
Printed by Ebenezer Baylis and Son Ltd. Worcester.

Contents

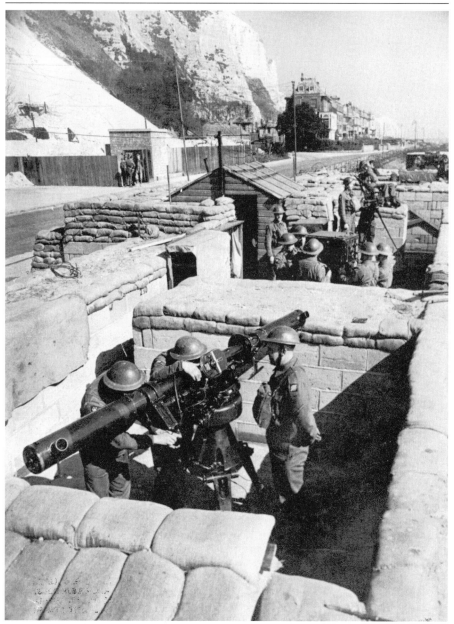

In 1942 the ack-ack site on Dover seafront was still equipped with the ancient 3 in guns of First World War vintage. The battery equipment included the Barr & Stroud range-finder, mechanical computer (*Predictor*) and a deck-chair-mounted 'Spotter' with his binoculars. The houses on the left were occupied by the Royal Navy and WRNS, while the white chalk scar below the cliffs is spoil from new tunnels excavated below Dover Castle.

Introduction

During the Second World War, East Kent gained several names from the popular press, the best known being 'Hellfire Corner'. Indeed, this part of England suffered over a continuous period of five years: bombs, land-mines, shells, V1 pilotless planes, aircraft crashes and, on more than one occasion, torpedoes! However, from the outbreak of war on 3 September 1939 to the liberation of the Channel ports and the capture of the German long-range guns opposite Dover on 30 September 1944, people in the area carried on as normal a life as was possible.

Until the evacuation of Dunkirk in May 1940 the war was seen by many local residents as something which was happening 'over there', and it was not until the evacuation of a large portion of the population that East Kent awoke to find itself in the front line. The strong Army presence in towns such as Dover, Folkestone and Canterbury accustomed people to seeing the Army around their streets, while Dover had strong links with the Royal Navy forged during the First World War. Local RAF aerodromes at Manston and Hawkinge had seen increased service activity since 1938, together with flying training by the Civil Air Guard at the civilian airfields of Bekesbourne, Ramsgate and Lympne.

In 1939 the first sign of hostilities was the mobilization of the local Territorial Army battalions to man coastal defence guns around the harbours, many of them of First World War vintage. Anti-aircraft guns, searchlights and 'sound locators' appeared in fields or on the hills, and the first Army conscripts were seen digging trenches or erecting barbed wire defences. Naval activity increased as the Navy took over at Dover and the familiar cross-Channel train ferries were turned into minelayers. The 7th Destroyer Flotilla and its support vessels had now occupied the harbour, while requisitioned tugs, trawlers and drifters of the RN Patrol Service resumed duties undertaken by former 'Dover Patrol' vessels of the First World War, by searching shipping from neutral nations in the Downs off Deal. The Fleet Air Arm occupied Lympne temporarily, while some French Air Force squadrons arrived to stay for a few weeks.

The Dunkirk evacuation, masterminded by Vice-Admiral Ramsay in the 'Dynamo Room' under Dover Castle, involved many local vessels, even fishing boats from Deal beach, as well as anything from Channel ferries to Dutch skoots and French and Belgian trawlers, together with famous 'little ships' of the weekend sailors. Local lifeboatmen volunteered their services, but at those stations which declined, their vessels were requisitioned and manned by the Royal Navy. On landing at Dover, Margate, Folkestone and Ramsgate onward transport involved the Southern Railway and East Kent Road Car Co.

Hardly had 'The Miracle of Dunkirk' passed than East Kent came under the onslaught of the Battle of Britain; convoys were bombed and shelled and then it was the turn of local towns to suffer much damage and a large number of casualties. People spent many nights in tunnels under Dover and Ramsgate or in Anderson shelters in their back gardens. Aircraft from both sides crashed or force-landed, and in the villages the schoolchildren rushed around on bikes collecting souvenirs. Farmers, aided by Women's Land Army 'landgirls',

ploughed and harvested to help keep the nation fed. Country railway halts had their sidings occupied by guns, while behind the cliffs of St Margaret's Bay the first long-range artillery pieces were soon being installed.

By 1941 thoughts had already turned to the re-occupation of the mainland of Europe, and the first commando raids across the Straits of Dover saw MTBs and MLs landing reconnaissance parties to gather what information they could about German coastal defences. In February 1942 the 'Channel Dash' by three German capital ships up the Channel saw a combination of atrocious weather, and a serious miscalculation by the defenders. The heroic attempt by No. 825 FAA Squadron, flying from Manston in their frail Swordfish torpedo-carrying biplanes, combined with a hurriedly mounted operation by RN Light Naval Craft, did not stop this armada's progress – eventually halted by the chance encounter with a sea mine. However, 'Operation Bodyguard' had now started, which was designed to convince the enemy that any invasion attempt was to be mounted from this part of south-east England. Fake radio stations distributed messages to fictitious battalions, while by 1943 troop exercises were undertaken in the hope of being witnessed, and reported, by enemy agents who had been allowed to remain active – just for this reason.

As D-Day approached, the deception increased as the dummy landing craft occupied Dover and Folkestone harbours; inflatable tanks and the vast tented camps were visible while the build-up of Army vehicles and shell and bomb storage areas were carefully camouflaged from sight. As aerial activity increased, RAF fighter-bombers blasted defences along the French coast, from the Pas de Calais to Normandy, and bombed road and rail communications inland. American heavy bombers, escorted by fighters in great waves, pounded troop concentrations and armour, while by night RAF bombers and night intruder aircraft attacked airfields. Again, it was the coastal airfields of East Kent which received battle-damaged aircraft, limping over the Channel low on fuel, often forced to land short of their goal.

Suddenly it was D-Day and troops on the cliffs watched in amazement as huge sections of Mulberry harbour were towed past, and vast convoys of troop-ships, escorted by all manner of vessels, ran the gauntlet of enemy shelling. Our long-range guns pounded the enemy positions and later sunk their vessels in their own 'Dunkirk'-style operation. Within a week of the invasion, Kent was to witness the V1 pilotless plane attack on London, when many were shot down or diverted by fighters, or became the victims of the massed ranks of anti-aircraft guns lined up along these coasts. Later, the Allied armies were kept supplied with fuel by means of the underwater pipeline 'Pluto', run from Dungeness; and landing craft and train ferries transported anything from heavy railway locomotives to jerrycans of water from Dover to Calais, Boulogne and Dunkirk. On 30 September 1944 'Hellfire Corner' could now relax after the final German long-range guns were captured, and there was literally 'dancing in the streets'.

Thus ended five years of pain and suffering by both military and civilians alike, leaving many a battle-scarred street in towns and villages; chalk-filled craters in farmers' fields; and a task of demolishing pillboxes or anti-tank defences, clearing minefields, and removing miles of barbed wire. Life in East Kent would never be the same again.

Prelude to War: 1938–9

Preparations for the inevitable outbreak of hostilities had been made since the Munich Crisis of September 1938, when local Air Raid Precautions involved the setting up of Warden's Posts, provision of surface shelters, and training of Civil Defence Heavy Rescue Squads and medical auxiliaries 'just in case'. Mobilization of Army Territorials and RN and RAF auxiliaries was the dress rehearsal for events only one year later, while the fear of immediate bombing raids and gas attack led to the excavation of a labyrinth of tunnels under Ramsgate, and gas masks issued to the civilian population. When war broke out the sheltered anchorage of the Downs was crowded with neutral shipping awaiting examination by RN Contraband Control, and 'ablaze with light by night like a small town', while the lights of Deal, Dover and Ramsgate were blacked-out under the vigilant eye of ARP Wardens. At Dover and Ramsgate harbours both minelaying and minesweeping craft were soon assembled; many of the latter were converted motor fishing boats while the former included two former Southern Railway cross-Channel train ferries. Aliens and potential enemy agents were moved out of the area, leaving a residue of enemy 'sleepers', despite an assurance that every enemy spy in the UK had been rounded up in September 1939.

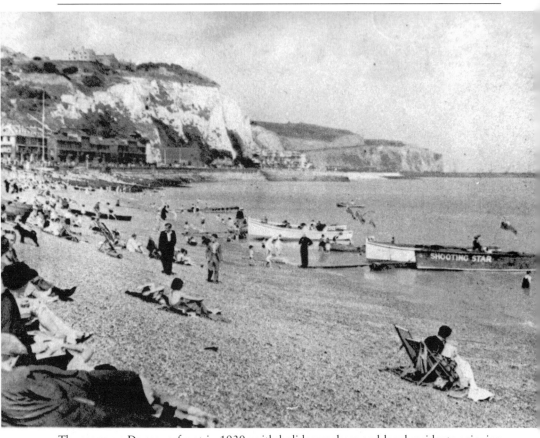

The scene on Dover seafront in 1939, with holiday-makers and local residents enjoying the last summer of peace. On the water's edge waits Johnny Walker's speedboat *Shooting Star*, which was to be destroyed, and its owner killed, by a bomb on 11 September 1940. Many houses and hotels facing the promenade did not survive the war, and the beach would soon be barred to visitors by barbed wire and mines.

An alfresco picnic for the RA gunners on the Eastern Arm at Dover during their last pre-war Summer Camp in August 1939. Left to right: Gnrs. Marsh, -?-, Hannagan, W. Skinner, Skippin, -?-, -?-, Nichols, Lance Bombardier Cunningham. The structure in the background is one of the pylons carrying an aerial ropeway from Tilmanstone Colliery to the coal saith at the end of the Eastern Arm.

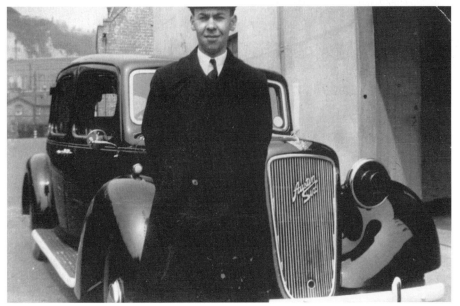

Young Bob Lawrence stands by the new Austin Six limousine, supplied to the Admiralty by The Continental Garage, Castle Street, for the naval Commander-in-Chief at Dover. Bob served as chauffeur to Vice-Admiral Ramsay and also drove many visiting VIPs, including the Prime Minister, during 1939 and 1940 until he volunteered for service in the Royal Navy himself in 1941.

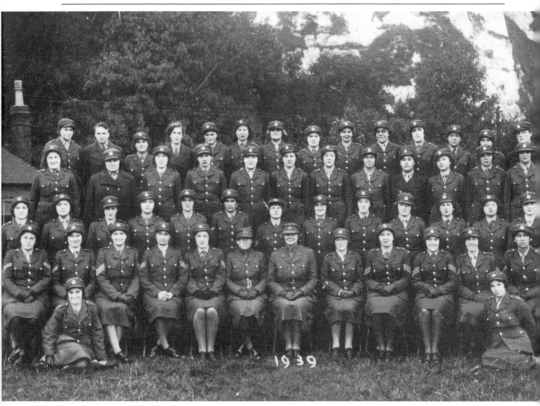

The 42nd (Kent) Company Platoon was one of the first ATS units to be formed and these ladies served as drivers, telephonists, cooks and as clerks at the Armaments Office at the Langdon Battery. Among those in this photograph, taken in the grounds of the old First World War RNAS seaplane station on Dover seafront, identified by Mrs May Owen are: '(starting in the middle) Divisional Commander Reid who lived at Kingsdown, Mrs Driffield-White also from that area, Phyllis Borman, who came from Deal, Ivy Bishop who was in Major West's office, Cpl. Clark, who was Major West's driver, Sgt. Cook Hougham, Peggy, who used to work in the cookhouse, Sgt. Gallop, a girl named Winston, and Mertyl Thompson who was in the 519th Battery office.'

The local Royal Artillery TA at Ramsgate was equipped with this 25-pounder gun to defend the local harbour. It was situated on the promenade in front of the old Ramsgate harbour railway station, then the 'Merrie England' entertainment complex. The 170th Battery RA was posted to Dover upon the outbreak of war and manned the harbour defence guns on the Admiralty Pier.

The Tilling-Stevens Petrol-Electric lorry was part of the equipment of the 468th (Cinque Ports Coy.) Royal Engineers A/A searchlight unit that was based at New Romney. On the outbreak of war it was deployed in support of anti-aircraft guns around local villages at Shepherdswell, Selstead, Swingfield and Aylesham, as well as around Dover and Folkestone, while their company headquarters was at Wingham.

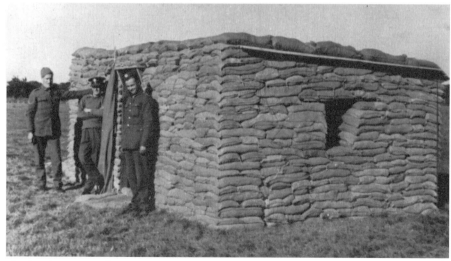

The headquarters of No. 4 Section of 468th Searchlight Coy. RE was at Upton Wood, Shepherdswell. Improvised from sandbags, the entrance door and corrugated iron roof came from Lydd camp, while the wind-down windows were old car doors scrounged from Lines Brothers, Lydden car breakers, by Section Sgt. Richard Body. He also scrounged a dozen oil drums from Arter Brothers of Barham for their field ovens.

The promenade at Sandgate, near Folkestone, had minimal defences prior to the fall of France, when this lone solider was engaged in uncoiling rolls of barbed wire along the sea wall (note the gloves in his back pocket). After June 1940 pillboxes, minefields and machine-gun posts lined the promenade, backed up by coastal defence guns atop the cliffs, with the associated ack-ack batteries and searchlights.

The arrival of the RAF at Lympne saw the erection of some First World War wooden huts to provide living accommodation on the western side of the hangar formerly occupied by the Cinque Ports Flying Club. Despite evacuating some of their aircraft to Sywell, Northants, in September 1939 and the dispersal of others to woods near the airport, when the hangars were bombed in August 1940 many aircraft were destroyed in the ensuing three-day blaze.

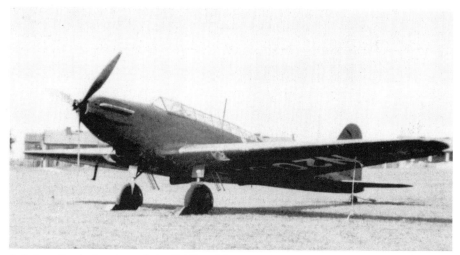

A Fairey Battle bomber of the RAF at Manston in 1939, serving as part of the Air Component of the British Expeditionary Force in France in 1939. In the event poorly armed light bombers proved no match for a determined Luftwaffe, shown by their heroic attack on the Maastricht bridges in May 1940. They were later pressed into service to help destroy the invasion barges in Calais, Boulogne and Dunkirk, but by night!

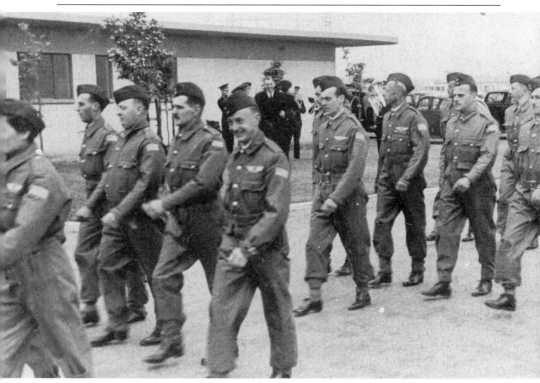

The Thanet Civil Air Guard paraded at Ramsgate Municipal Airport when the salute was taken by local MP Capt. H.H. Balfour, MC, Under Secretary of State for Air. John Roots smiled as his sister 'snapped' the local section passing the new airport terminal building. The Civil Air Guard training was designed to provide a reserve of pilots at the outbreak of war, but few members ever served in the RAF.

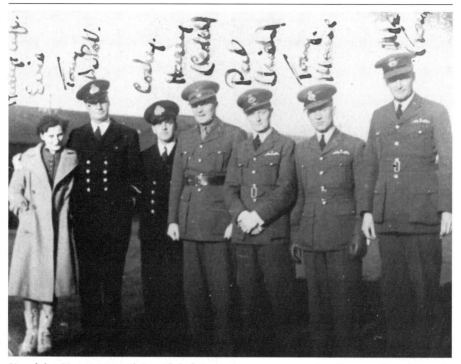

Six of the Cinque Ports Flying Club flying instructors returned to Lympne Aerodrome in uniform after the outbreak of war. Left to right: Evie Thynne (former secretary), Tony Duport, 'Cocky' Cockburn (FAA), Harry Thynne (RA), Pat Udinech, Tony Morris, Tom Hackney (RAFR). Despite the number of hours flown while civilian instructors, the RAF insisted that the three latter pilots had to 'pass-out' to their satisfaction.

The first wartime occupants of Lympne Aerodrome were the Fleet Air Arm, who by September 1939 had taken over as a sub-station of Lee-on-Solent, naming the airfield 'HMS *Buzzard*'. Initially used for training clerks and wireless operators, naval aircraft, such as these Blackburn Roc fighters, visited on occasions. By August 1940 the Royal Air Force had arrived and most civilian aircraft had been evacuated.

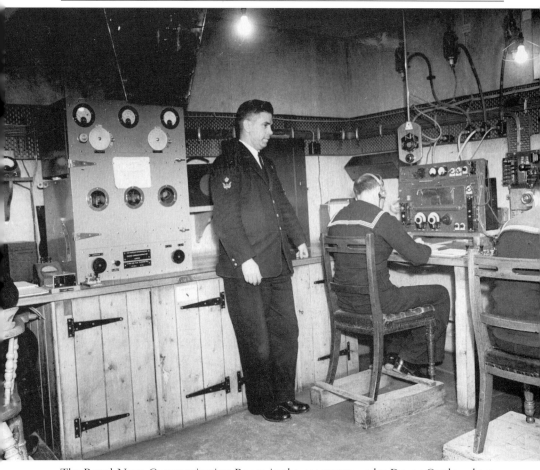

The Royal Navy Communication Room in the casemates under Dover Castle, where a RNVR telegraphist Charles Syed arrived on 28 August 1939. He recalls, 'we had to face our first enemy in the hoards of bats and rats which lived in the tunnels'. It was here that he received an Admiralty signal on 3 September 1939 with instructions to 'Fuse all warheads – prepare for war'.

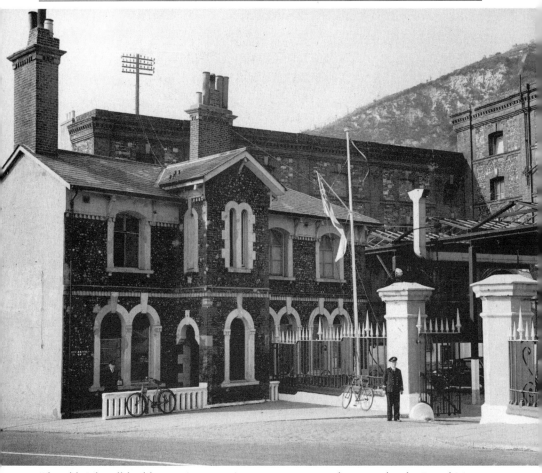

The old Oil Mill building in Snargate Street, Dover, was taken over by the Royal Navy as their Sick Bay, marked by a white ensign flown at the entrance. Bicycles parked by the fence were used for transport to HMS *Wasp*, the old Lord Warden Hotel or the harbour. Behind were the caves in which locals had sheltered from Zeppelin attacks during the First World War. These caves were used again in the Second World War by the WRNS from HMS *Wasp*.

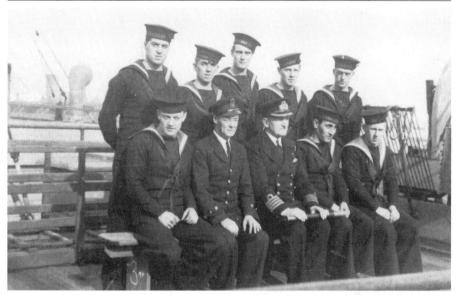

Capt. Freyburg RN and Southern Railway crew members of minelayer HMS *Hampton* wearing their new uniforms. Two Southern Railway's train ferries, *Hampton Ferry* and *Shepperton Ferry*, were requisitioned by the Royal Navy as minelayers in September 1939, and converted at Portsmouth for minelaying before returning to Dover. Their regular crews were supplemented by Clyde Division RNVR personnel from Scotland.

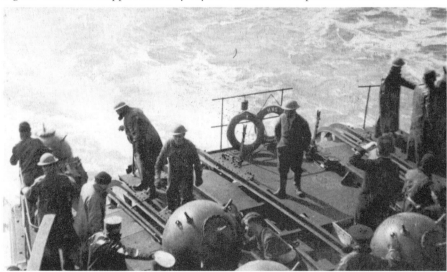

Between December 1939 and May 1940 mines were laid in the Channel and southern North Sea by HMS *Hampton*, HMS *Shepperton*, and two Royal Navy minelayers. The cradles for the mines were launched over the aft end of the train deck, being run out on the narrow gauge railway lines welded between the existing train tracks. Some 300 mines and 300 bags of coal were taken aboard at Dover every three days.

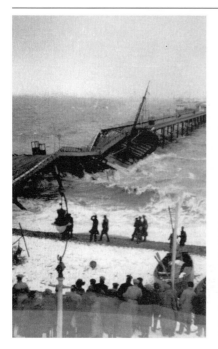

The Dutch skoot *Nora* smashes against the Deal Pier on 21 December 1939 after being mined while anchored in the Downs for her Contraband Control checks. Despite warnings by local boatmen, she was beached to the south of the pier on a rising spring tide and south-westerly gale forecast. Watched by crowds on the promenade, the *Nora* took several hours to batter through the iron piling of the Victorian pier.

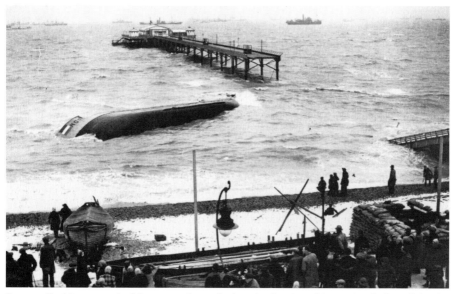

Eventually *Nora* smashed her way through the pier leaving this gaping hole, while she capsized in the shallows scattering wreckage and slabs of strawboard along the shoreline. Vessels awaiting Contraband Control checks can be seen on the horizon, while locals comb the beach for souvenirs. At least the Royal Engineers, detailed to blow a gap in Deal Pier as an anti-invasion precaution, were thus saved a job.

SECTION TWO

Dunkirk and After: 1940

Indications that all was not going well within France had only dawned on the citizens of Ramsgate when they awoke on 27 May 1940 to find dirty and dishevelled soldiers roaming the streets seeking food and a 'cuppa'. At Dover John Hartly thought a contingent of RAF men he saw marching to the railway station was a scruffy bunch, while Mary Osborne witnessed an impromptu service that Revd Daniels held on Deal seafront when crews of local fishing boats departed for Dunkirk. Thousands of British, French, and Belgian troops, a few civilians and numerous dogs were brought into East Kent ports, transported to local railway stations, fed and watered, and sent on their way, all in the matter of nine days. With the enemy on the French coast, only 22 miles away, immediate invasion was threatened, and defences in East Kent were hurriedly strengthened. Trenches were dug and pillboxes built by men of local building firms organized into gangs, along with unemployed men, while the Army laid minefields, installed barbed wire entanglements, built road blocks and dug tank traps. Mr Anthony Eden's call for Britain to raise a Local Defence Volunteer force led to crowded police stations as queues of volunteers formed to join 'Dad's Army'.

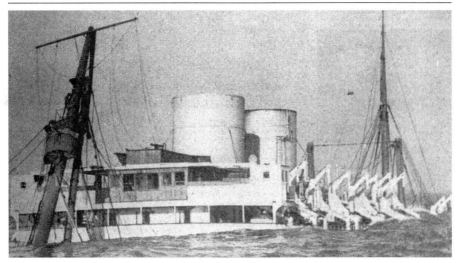

One of the first ship casualties of 1940 was the liner *Dunbar Castle*, which struck a mine off North Foreland on 9 January. Among those landed at Deal was a steward who had missed attending a local wedding reception as he had been unable to obtain leave; while one oil-stained child, escorted to safety by nuns, was thought to be a Coloured lass until her coating of oil was removed!

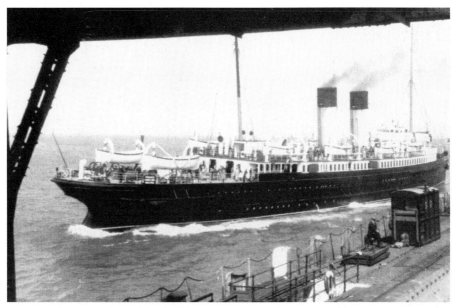

Until the fall of French and Belgian Channel ports, ferries operated a normal service, including the SS *Maid of Orleans* of the Southern Railway, seen here departing Folkestone in January 1940. Walking her decks were Army officers returning from Christmas leave, while a lone member of the shore force sits on a bollard adjacent to a container used for Registered Mail or luggage.

Royal Marine bandsmen, members of the crew of HMS *Exeter*, assembling in the forecourt of Deal station upon their return to Deal depot after the 'Battle of the River Plate' on 28 February. It caused much interest, and although their uniforms were hidden by khaki greatcoats, the parade provided a much needed spectacle to cheer up the long bleak winter months.

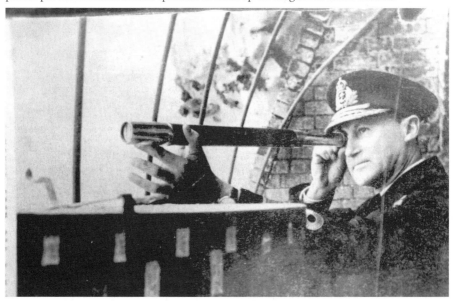

Vice-Admiral Bertram Ramsay takes a break on the balcony at the end of the tunnel leading from his office, housed in the casemates under Dover Castle. Here he masterminded the evacuation of the BEF via Dunkirk under 'Operation Dynamo'. The name was derived from some generating equipment formerly housed in the casemates during the First World War.

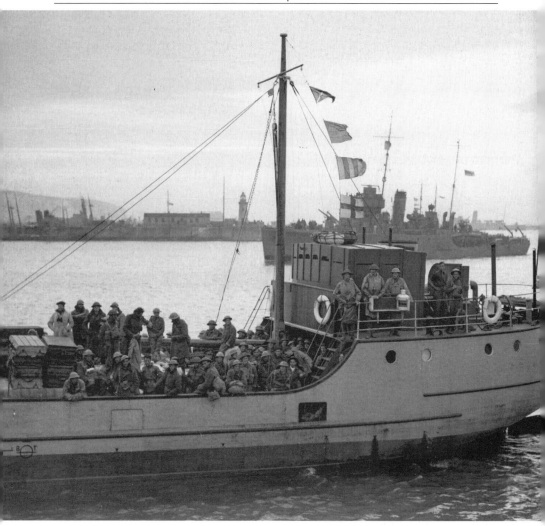

A British coaster arriving at the Admiralty Pier, Dover, escorted by a British destroyer and loaded with Dunkirk troops. Dover handled the largest number of evacuees because rail facilities were available to dispatch them to inland destinations. In the background, tied up at the Prince of Wales Pier, are some minesweeping trawlers and drifters, and in the distance, alongside the Eastern Arm, is the destroyer depot ship *Sandhurst*.

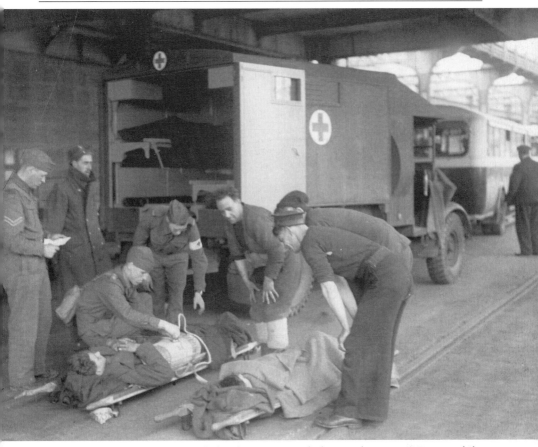

Two wounded soldiers are attended to by RAMC orderlies on the quay at Dover, while, in the background, requisitioned East Kent buses wait to transfer the walking wounded to the ambulance trains at the nearby railway station or to the hospital. Many ships were bombed or machine-gunned, leaving the RA gunners on the Eastern Arm the unpleasant task of clearing up the results of the carnage caused on board, before the vessels could return to France for yet another load.

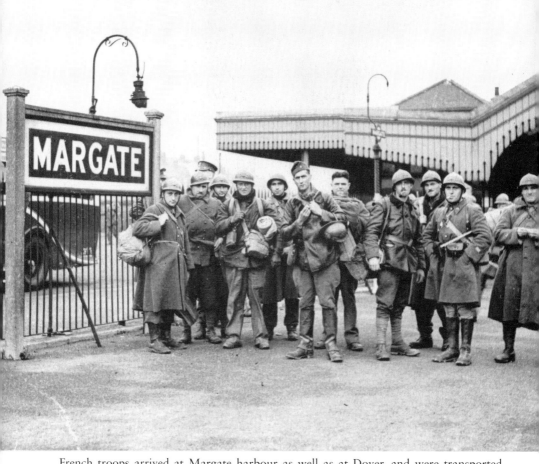

French troops arrived at Margate harbour as well as at Dover, and were transported from the harbour to the railway station by buses. At The Casino tea and piles of sandwiches were prepared by the WVS, and if troops were without items of clothing they were re-equipped. As Rosa Green recalls: 'I saw one Indian soldier strike a humorous note by marching past, with a wide grin, wearing a mackintosh coat and a pair of plus-fours.'

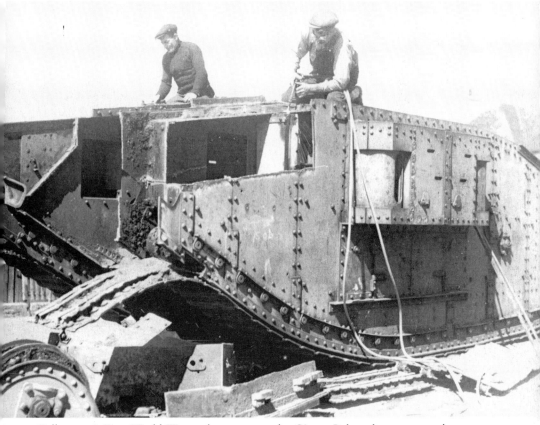

Folkestone's First World War tank was cut up by Ginger Baker, the scrap merchant, as part of the 'Scrap Drive' which led to the loss of garden railings, ornamental balustrades and park gates throughout East Kent. The tank, which stood on The Durlocks overlooking the harbour, was presented to the town in July 1919 as a reward for its efforts towards War Savings during the earlier conflict.

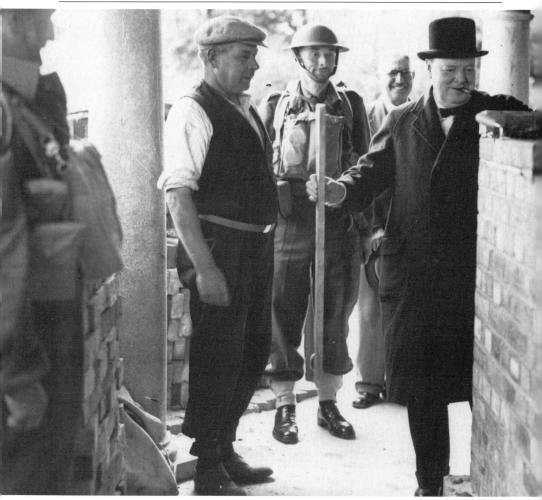

Folkestone building contractor, Mr Otto Marx, watches as Mr Churchill lays a
symbolic brick at one local pillbox, under the critical eye of foreman Fred White.
Someone in the crowd remarked, 'I hope he's got his union card', at which 'Winnie'
produced one from his pocket having been made an honorary member of the
Bricklayers Union after his activities at Chartwell during the 1930s.

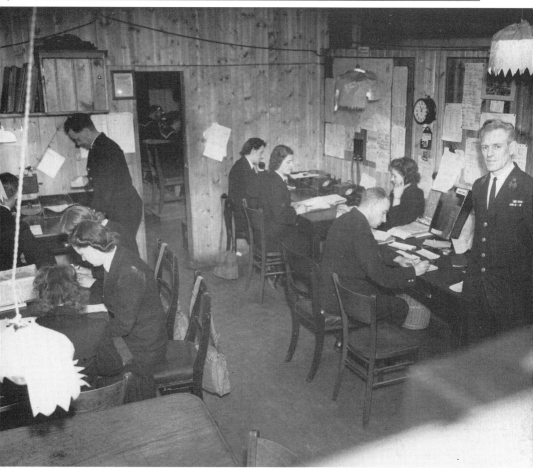

The RN Codes and Cipher Department, in the casemates under Dover Castle, was situated adjacent to the Communications Room (through the doorway). Here, Wrens received out-going messages for encoding before despatch, or decoded in-coming messages for the naval Commander-in-Chief Vice-Admiral Ramsay, under the watchful eye of Chief Petty Officer Files (right). These girls were some of the first Wrens to serve at Dover and were billeted at Dover College.

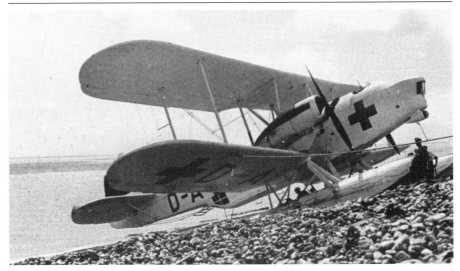

This Air-Sea Rescue seaplane had been forced down off the Goodwins on the evening of 9 July 1940 by the Hurricanes from No. 54 Squadron based at Manston and later beached at Walmer. The Heinkel He59Bs of Seenotflug-kommando 2 were suspected of monitoring convoy traffic and 'spotting' for coastal guns, so were ordered to be shot down on sight even though they carried the International Red Cross symbol.

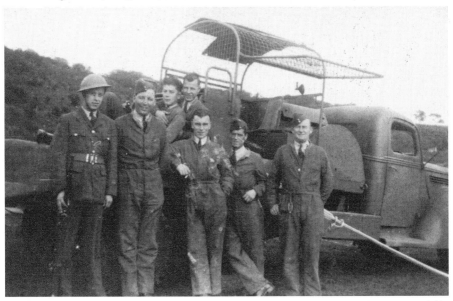

Some of the crew of a balloon winch manned by RAF No. 961 Squadron at Crabble Athletic Ground, Dover, during the summer of 1940. Their balloons were regularly shot down by marauding Messerschmitt fighters, but quickly replaced by new ones. Note the RAF sharp shooter (left) and a wire cage on the winch to protect crew against falling steel cables.

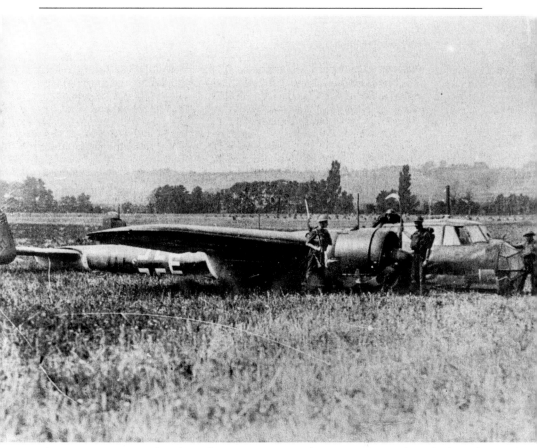

This Dornier Do17Z bomber of 7KG2 was an early morning arrival at Stodmarsh returning from an attack on Eastchurch Aerodrome, Isle of Sheppey, on 'Eagle Day', 13 August 1940. Engaged off Whitstable by Hurricanes of No. 111 Squadron, this aircraft crossed Canterbury before being forced to land near the ack-ack site, where John Shilson recalls, 'we were roused from our slumbers to man our Bofors gun clad just in boots, tin hats and our underpants – I shuddered to think what the German crew thought of the British Army!'

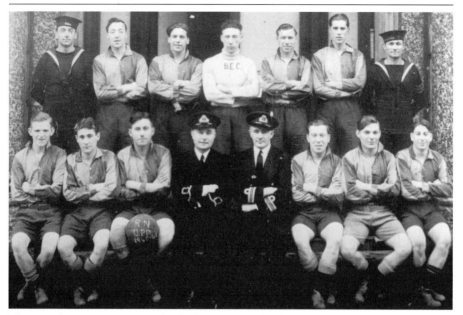

The Royal Navy UPP party football team outside their quarters in HMS *Wasp*, the former Lord Warden Hotel in Dover. Royal Marine Doug Bulger recalls that their 'rocket guns', based on the Prince of Wales and Admiralty Piers in Dover, could be fired singly or in a salvo of twelve, and claimed at least three enemy aircraft. Cables from the PAC rockets fell around the harbour, but made good fishing traces.

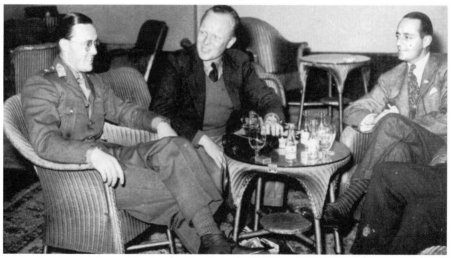

Relaxing in the Lounge Bar of the Grand Hotel, Dover, Crown Prince Bernhardt of the Netherlands chats to American war correspondent and radio broadcaster Ed Murrow. Mr Banner from the British Ministry of Information listens in to prevent any security leaks. The Grand Hotel was badly damaged by an enemy bomb on 11 September 1940 when many RN and civilian personnel were killed or injured.

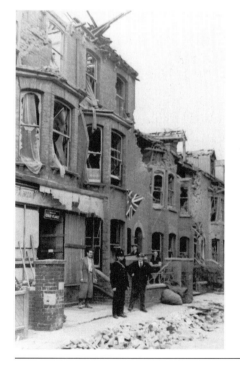

Flying serenely over Deal, this Heinkel He111H bomber released a stick of bombs which can be seen below the aircraft. Deal became targeted as it contained the Royal Marine barracks, the main line from Dover to Ramsgate, gas, water and electricity installations, and was occupied by troops defending the coast against the threatened invasion. This photograph was taken by Bill Fenn from his back garden in Telegraph Road.

Property in Blenheim Road, Deal, suffered most bomb attacks as it ran alongside the main railway line and was situated near the station. The local sub-post office was severely damaged in the raid of 22 August 1940, and it later had to be demolished. Occupants of damaged houses nearby sought new accommodation away from the vulnerable area, or 'slept-out' with friends on the outskirts of town.

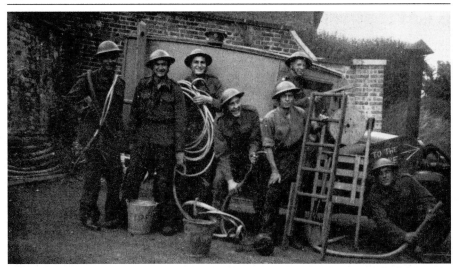

The fire picket, from the Royal Engineers Repair Party, was based at Archcliffe Fort, Dover, for the installation and maintenance of the diesel generators used to power coastal defence searchlights at local harbours and coastal gun batteries. Transport by lorry during the Battle of Britain became a somewhat hazardous operation, and the DCRE Repair Party vehicles were machine-gunned on several occasions.

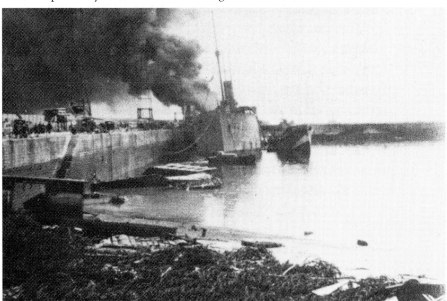

The result of the enemy dive-bomber attacks on Dover harbour on 27 July 1940, with Destroyer Reserve Flotilla depot ship *Sandhurst* on fire, and the wreck of flotilla leader HMS *Codrington*, with a broken back, alongside her. Three George Medals were awarded to Dover firemen for their heroic work aboard the *Sandhurst*, which was eventually saved and towed away from Dover two weeks later.

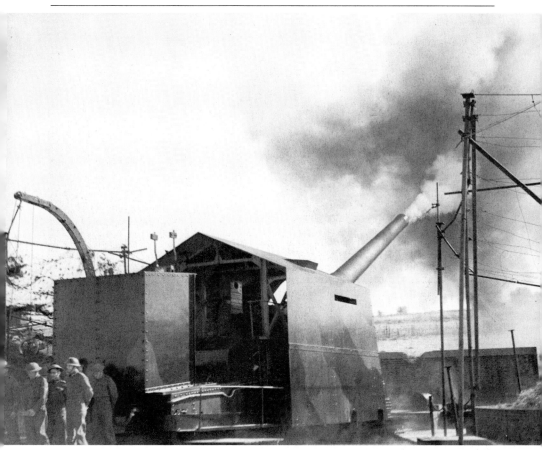

The Royal Marine Siege Regiment manned two 14 in ex-naval guns installed on the old St Margaret's Golf Course in August 1940. *Winnie* was only capable of reaching the coast of France. *Winnie* (named in honour of Winston Churchill who instigated the idea in response to the German gun batteries) and *Pooh* were hydraulically operated and were thus too slow to follow and engage enemy shipping.

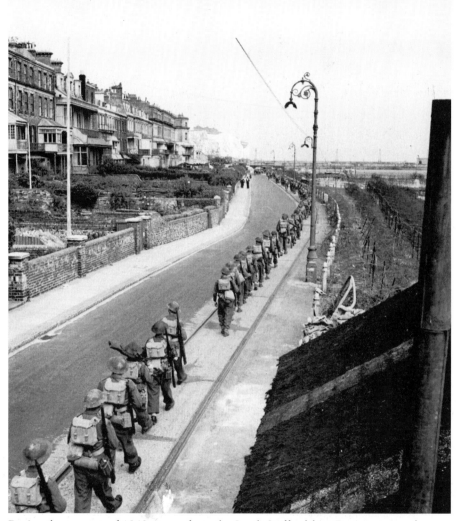

During the summer of 1940 troops from the South Staffordshire Regiment, seen here en route to the Eastern Docks, helped defend the coastal area of East Kent. Barbed wire entanglements on the right protected the beach from a surprise landing, although the company was in possession of only one Bren gun to defend the area between the River Stour estuary and Hythe.

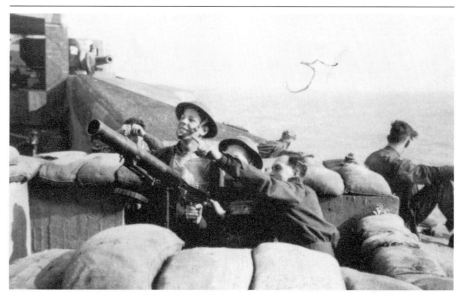

On 13 October 1940, whiling away their autumn days when manning the two 6 in coastal defence guns on the breakwater (background), members of 159th Battery keep a wary eye out for enemy attack, either from the sea or the air. Two gunners keep watch across the Channel, while three others pose at their ancient Lewis machine-gun, in its sandbagged emplacement on the parapet.

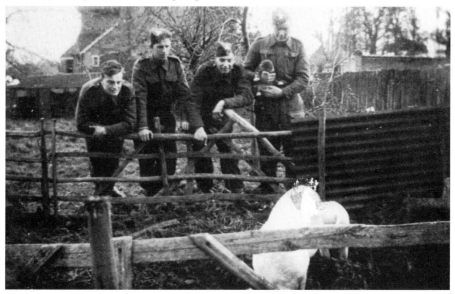

Local enterprise by 74th Troop, Med. Regiment RA, involved the acquisition and rearing of pigs, installed in their purpose-built sty at the Brook House Battery headquarters. They were fed on waste from the cookhouse, and here Gnrs. Bunton, Baker and Wilson, with L/Bdr. Hogan admire their Christmas dinners in the making.

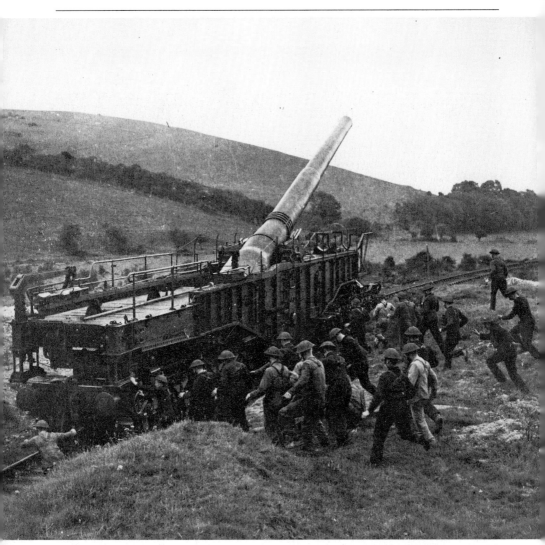

Members of 'B' Battery, Royal Marine Siege Regiment, run at the double to man HMG *Piecemaker* at the Gun Park near the old colliery siding at Stone Hall, Lydden. When this 13.5 in gun arrived in East Kent it had to be accommodated on a temporary railway spur line from November 1940. Together with its companions *Gladiator* and *Sceneshifter* it was later to be deployed in the Guston rail tunnel, or at the Martin Mill station sidings for use on firing spurs on the cliffs between St Margaret's Bay and Dover against any invasion fleet which ventured across the Strait of Dover.

SECTION THREE

Starting to Hit Back

When the Battle of Britain attacks finally petered out in November 1940, they were replaced by 'hit and run' fighter-bomber raids on the coastal towns of East Kent, so residents could not relax. Likewise, Army units based along the coast were still on maximum alert for a surprise attack if not a full-scale invasion. During the winter months the nightly Blitz on London continued, and much of this enemy bomber traffic crossed East Kent, occasionally dropping their bombs on the way home, prior to risking the hazards of the Channel crossing. A feared resumption of the mass bomber attacks on London, and the south-east, did not materialize in spring 1941, although measures had been taken to combat this by the installation of high-angle weapons on the coast between Dover and Folkestone. Combined with the transfer of most Luftwaffe Gedeschwaders from the Pas de Calais to the Eastern front it gave the RAF opportunities to undertake probing missions over France and Belgium to tempt remaining enemy aircraft into combat. A constant vigilance was needed to keep the Strait of Dover clear of minefields laid by enemy surface craft or seaplanes, while the RN Light Coastal Forces sought to engage both 'E' boats and enemy minesweepers by night.

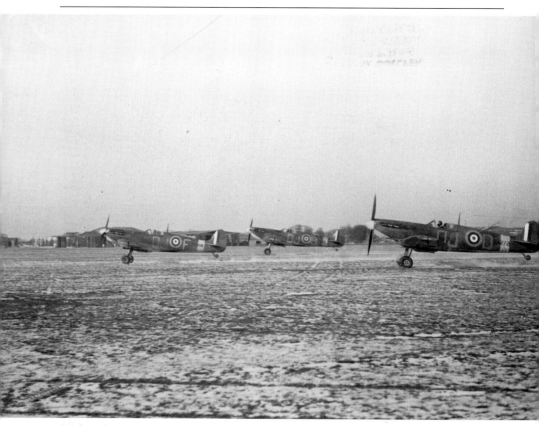

Spitfires from No. 92 Squadron taking off from Manston in January 1941 to undertake a 'sweep' over France, while in the background the burnt-out remains of the hangars of East Camp remind pilots of the attacks the aerodrome had suffered the previous summer. On the right can be seen the two wooden aerial towers of the Wireless Station, which would seek to guide them safely back to base after their mission.

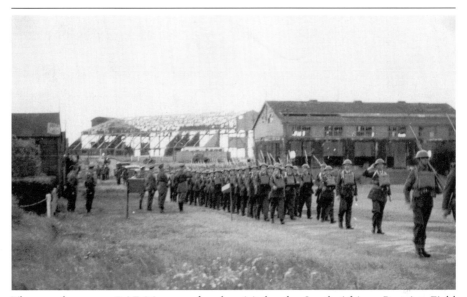

The march-past at RAF Manston for the visit by the South African Premier, Field Marshal Jan Smutts, took place in early 1941. Although some twelve months after being damaged, the skeletons of 'X' and 'Y' hangars were still visible behind the parade and it was not until the posting of the new Commanding Officer Tom Gleave that any start on clearance work was undertaken.

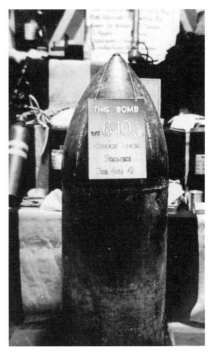

The case of an unexploded bomb that was dropped on Clarabutt's Store, Deal, on 2 February 1941 and eventually finished up in the window of the Marks & Spencer store next door. Here it is on display at Deal Town Hall as part of the fund-raising 'War Weapons Week'. While guarding the UXB one of a pair of Special Constables idly kicked the bomb. 'If that goes off', said his companion, 'we're going to get into serious trouble!'

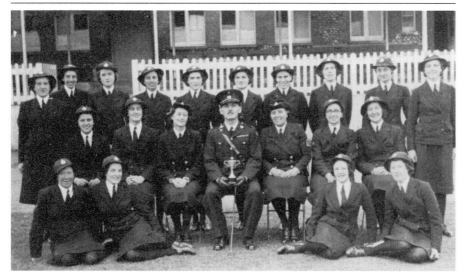

Some of the first Wrens to serve at the Royal Marine depot, Deal, with the cup their rifle squad won in an inter-unit shooting competition in 1941. Photographed with their instructor Col. Sgt. Weale, others so far identified include, in the back row, L/Wren E. Perkins, WRNS Binks, le Hain, Nye, and 'Mina'; in the middle row is Wren Bradley with Wrens Gee and Jeffries in the front. These ladies were known as Mar(ine) Wrens.

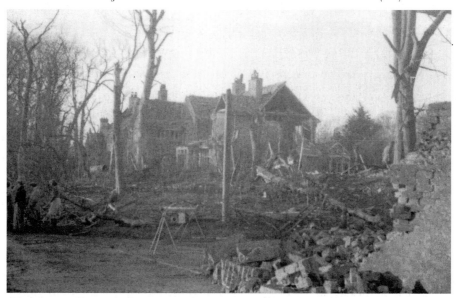

On the evening of 14 April 1941 damage was caused to 'Fiveways', Sholden, by a parachute mine (converted sea mine dropped by aircraft). The house of Alderman Stebbings, JP, was demolished, and the nearby Church of St Nicholas was badly damaged. In a pair of houses opposite, Mr and Mrs Tom Riches were blown from their bedroom through the party wall into their neighbour's – while still in bed!

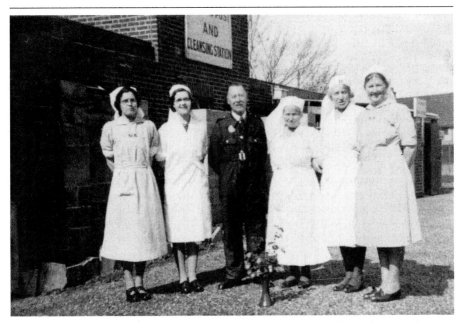

Local First Aid Posts, such as the one at the clinic in Victoria Park, Deal, were a boon to many local residents suffering from both shelling and 'hit and run' raids by enemy aircraft. Here, Civil Defence Warden Tom Hilson chats to some of the VAD nursing staff, after presenting them with a vase of roses from his garden.

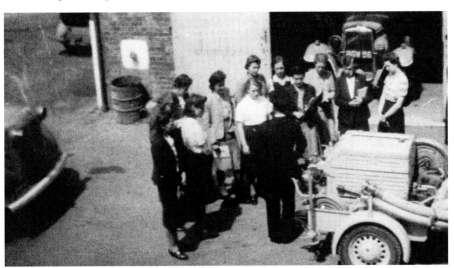

Lady volunteers for the National Fire Service, formed on 18 August 1941, receiving training at Denne's builders' yard at Upper Walmer. Trailer pumps, like the one in the foreground, could be towed either by the fire engines or civilian road vehicles, such as the car seen parked in the garage behind. This is either a requisitioned car, or it belongs to the NFS officer giving the lecture.

Apart from barrage balloons protecting harbours and important targets, another type of balloon was flown from East Kent involving 'M' Balloon Unit based at Manston, and later Kingsdown. Specially formed in 1939, it had the role of launching propaganda-carrying balloons towards the Continent, when the wind was suitable. As the bundles of leaflets had to be released using slow-burning fuses – combined with hydrogen-filled balloons – a forced landing often set fire to local farm crops.

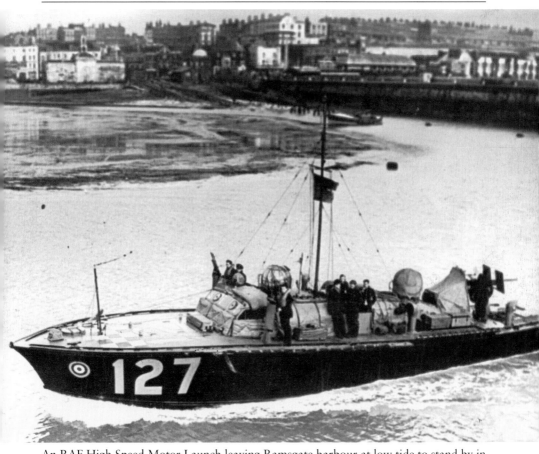

An RAF High Speed Motor Launch leaving Ramsgate harbour at low tide to stand by in the Channel to rescue any RAF pilots that might have to 'ditch' while returning from the Continent. In the background (right) is the camouflaged 'Merrie England' now known as HMS *Fervant*, a naval base for the MTBs and MGBs based in the harbour. Ramsgate had seen one of the very first RAF rescue launches in 1938, but due to mechanical faults, it was little used.

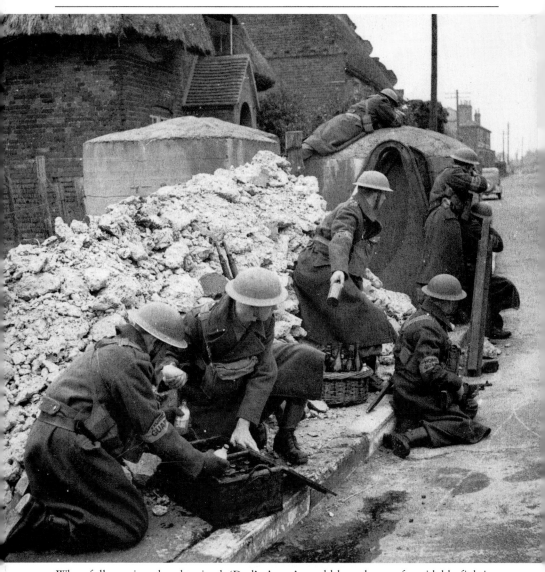

When fully equipped and trained, 'Dad's Army' would have been a formidable fighting force to repel any invader. Ideal conditions for this would have been in narrow village streets, such as at Ash-next-Sandwich, where the concrete road blocks would have been defended by a Molotov-cocktail-throwing Home Guard. Their reserve 'ammunition' is stored in some wicker baskets from Gardener's, the local brewery.

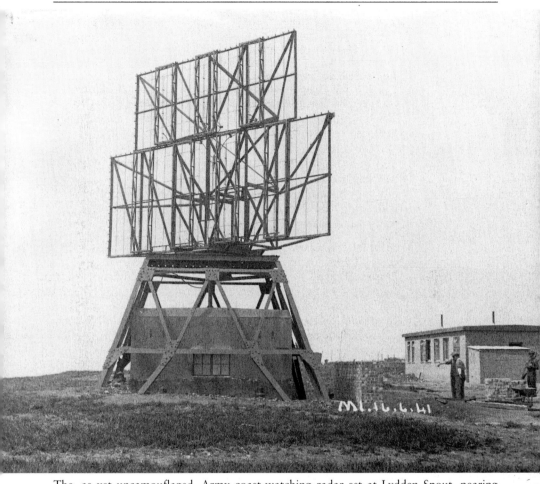

The, as yet uncamouflaged, Army coast-watching radar set at Lydden Spout, nearing completion on 6 June 1941. Six of the 'Baker' sets were positioned on the coast between St Margaret's and Dungeness. The lone soldier guards the aerial display on the technical block, housing equipment and a generator building, while watching two of the civilian workmen employed on the site.

Some of the first Army radar operators to man Lydden Spout M1 station included this group. Back row, left to right: Harry Shaw, George Salt, -?-. Middle row: Sergeant from South Foreland Radar (Frank Crown?), -?-, Harry Shaw (II) (radio mechanic), -?-, Sgt. of M1. Front row: L/Bdr. Sammy Vane, Ted Ashton (radio mechanic at M1), -?-, Jack Stobie. The operators plotted the passage of enemy convoys for the 15 in guns at Wanstone.

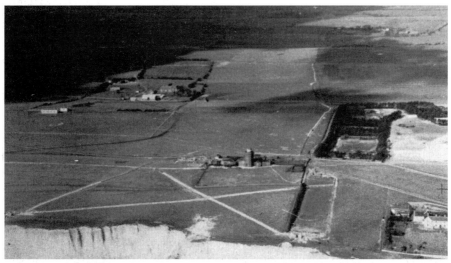

This view of South Foreland Battery shows the Battery Observation Post on the cliff edge (centre), Fortress Plotting Room East 2 (white scar), and the special radar set (cliff edge, right). Wanstone Farm is on the top left, later to be the site of two 15 in cross-Channel guns. Note that no attempt has been made to camouflage from enemy reconnaissance the prominent paths leading to BOP and radar set.

A Lewis machine-gun pit defending the Fan Bay Battery, where the 6 in high-angle guns were used as a 'Flash Battery' – firing blank rounds to lure enemy shipping to alter course towards the British coast to avoid their supposed barrage, thus bringing them in range of the twin 15 in guns at Wanstone Farm. Left to right: Charley Macey, Mac Menzies, Dai Jones, Gnr. Potter, Les Annetts (seated).

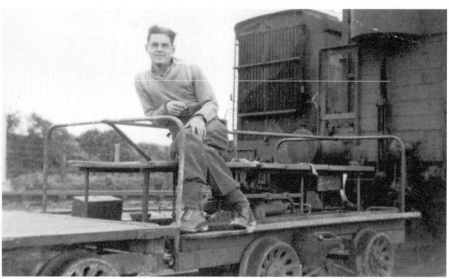

Sapper John Payne sitting on a Wickham petrol-engined trolley, used as transportation for personnel around the Martin Mill Military Railway. Sapper Payne was a 'blocksman' (signalman) working a small signal frame situated in the Martin Mill station building, as well as other signal blockposts. The overcrowding by sappers of Wickham trolleys was later banned after a serious accident.

Royal Marine Holding Battalion, Deal.

DANCE

in

THE GYMNASIUM, SOUTH BARRACKS

on

Monday, 15th September, 1941

ADMIT ONE

With the invasion threat receding, the Royal Marine depot at Deal was used for training both infantry and commandos, but could also provide some light relief from the rigours of war, as shown by this invitation for a RM Holding Battalion dance on 15 September 1941. Many women were now serving at the RM depot either as Wrens or in the NAAFI.

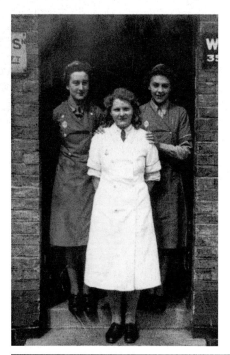

Standing at the door of the NAAFI, chargehand Emily Martin is flanked by Joyce Saunders (left) and Gladys Hoile (right), while taking a break from their duties. The signs beside the door provided information on the nearest fire points or water hydrants. This was most important as the depot at Walmer was hit several times by both bombs and shells, as well as being machine-gunned.

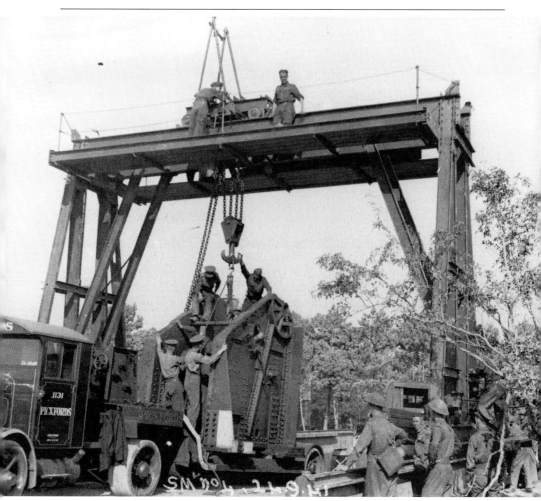

'Send for Pickfords – if you want something moved!' The cradle mounting for one of the 9.2 in guns at South Foreland Battery being slowly lowered into position on 24 September 1941. Although a civilian firm was employed to transport the cradle, the installation was undertaken by the Royal Artillery 'Gun Busters' led by Major 'Dickie' Shrive and his six-foot tall assistant 'Tiny'.

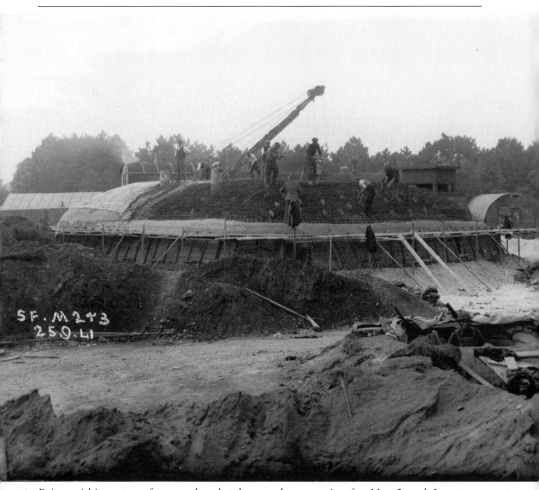

Being within range of enemy bombardment, the magazine for Nos 2 and 3 guns at South Foreland had to be protected by a concrete 'burster' to ensure shells exploded before penetrating the magazines with disastrous results. Civilian workmen are seen putting the finishing touches to this construction on 25 September 1941, and today one magazine is still preserved as a memorial to the local coast artillery.

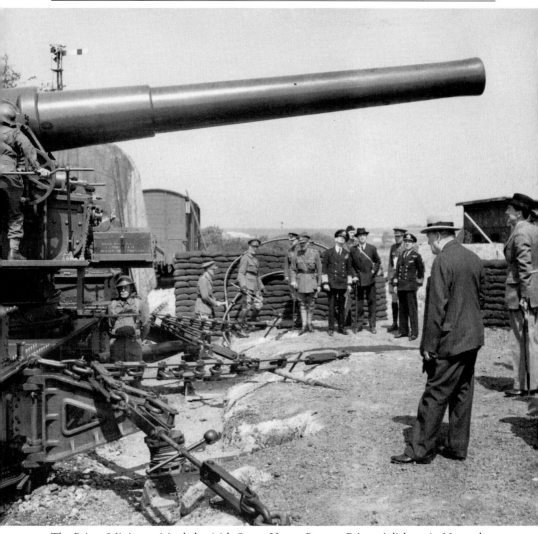

The Prime Minister visited the 16th Super Heavy Battery RA at Adisham in November 1941. Here, he is inspecting one of their two 9.2 in railway-mounted guns. Unlike the larger 13.5 in guns of the Royal Marine Siege Artillery, these guns could be fired at 90° to their mountings, and thus required chain pickets to stop them toppling over from their recoil. The Battery Commanding Officer, Col. Austin, is seen on the right, with some RN officers in the background.

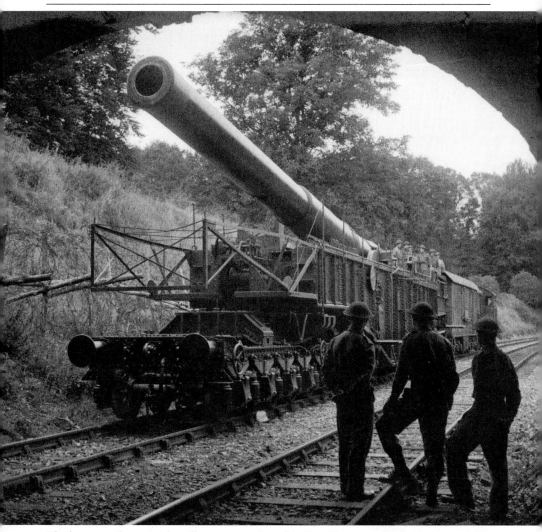

The largest rail-mounted artillery weapon based in East Kent was *Boche Buster*, a 16 in Howitzer which arrived at Bishopsbourne, on the Elham valley line (between Folkestone and Canterbury), on 3 February 1941. Operating along the curved sections of the line, it also had its own camouflaged 'hide' on the line near Kingston. Manned by 11th Battery, 2nd Super Heavy Regiment RA, it is seen here, together with ammunition wagon and diesel locomotive, outside an entrance to the Bishopsbourne tunnel. On one occasion, when firing a calibration round towards Deal, a large piece of shrapnel fell in the grounds of the Royal Marine depot at Deal. The following morning the Commanding Officer at Bishopsbourne received it back with a note attached asking 'Is this yours?'.

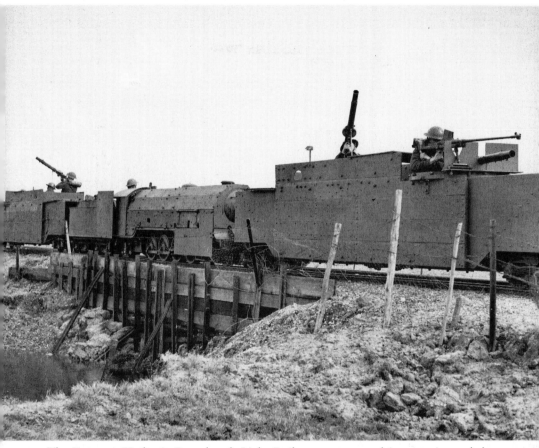

The Romney, Hythe & Dymchurch Light Railway was pressed into service to help defend East Kent against invasion. When the 6th Battalion of the Somerset Light Infantry took over the line in 1940, it was Capt. W.R. Ellis, their Adjutant, who suggested arming one train to patrol at dusk and dawn along the tracks across Romney Marsh. Two ballast wagons were each armed with Lewis machine-guns and a Boys anti-tank rifle, and together with one of the powerful 4–8–2 'Mountain Class' locomotives *Hercules*, they were protected by boiler plate to form the Miniature Armoured Train. Seen here at a reinstated bomb crater near Dymchurch, the train is believed to have shot down at least one enemy bomber returning home when it flew low across the isolated marshland never expecting to be fired upon.

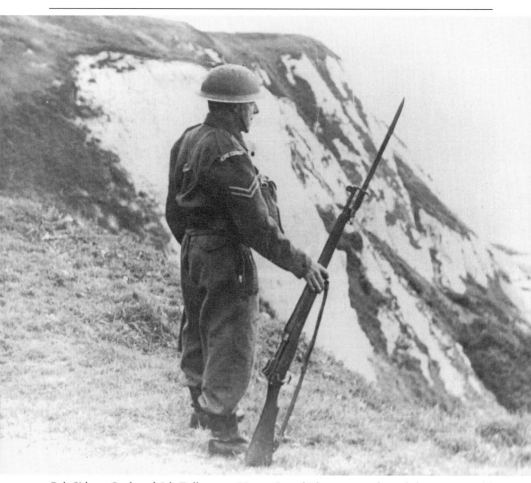

Cpl. Sidney Cocks of 5th Folkestone Home Guard Platoon stands with his First World War Lee-Enfield Mk 1 with the long-pattern bayonet guarding Capel-le-Ferne from invasion! As the Home Guard gained uniforms, arms and training it was drafted in to take over local defence duties from the regular Army units, so that the latter could be released to serve elsewhere in Britain or overseas.

SECTION FOUR

The 'Hit and Run' Bombardment

The enemy continued to raid the coastal towns of East Kent during 1942, using their Focke-Wulf FW190 fighter-bombers based at airfields in the Pas de Calais region. To counter these attacks the RAF fighter squadrons based at Manston and Hawkinge were given specific roles to play in combating the raids by catching the raiders before they could flee, at wavetop height, back to the safety of France. Radar stations on the coast were modified to enable low-flying targets to be detected before they reached our shores, while attacks were undertaken on enemy airfields by RAF bombers and fighter-bombers. In the Strait of Dover the anti-shipping operations against enemy minelayers and convoys continued, and during the year the Wanstone Battery at St Margaret's undertook radar-controlled shoots both at night and in bad weather. Monitoring of enemy radio traffic and jamming of their radar signals was undertaken from newly established installations such as the one at Hawksdown, Walmer. The year also saw the start of operations designed to deceive the enemy into thinking that an invasion attempt of their territory would be mounted from East Kent. Under the code name 'Bodyguard', sophisticated deception measures included spoof wireless traffic broadcast from an assortment of dummy radio stations; and Army exercises were carried on in full view of the local population to back up this deception.

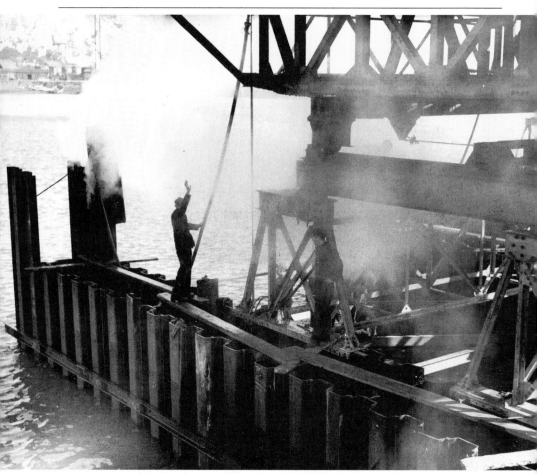

The reinforced concrete 'submarine pens' had been completed by a unit of Royal Marine Construction Engineers in the Camber at Dover harbour by early 1942. Although rarely used to house submarines they provided shelter for Light Naval Craft from the nightly shelling and regular bombing raids on the harbour. The only problem was the radio aerials on the RAF's High Speed Launches, which had to be lowered for each high tide or they fouled the roof. So well constructed were these pens that when demolition contractors started to clear them during the 1980s, it took some four months to remove this mass of steel and concrete.

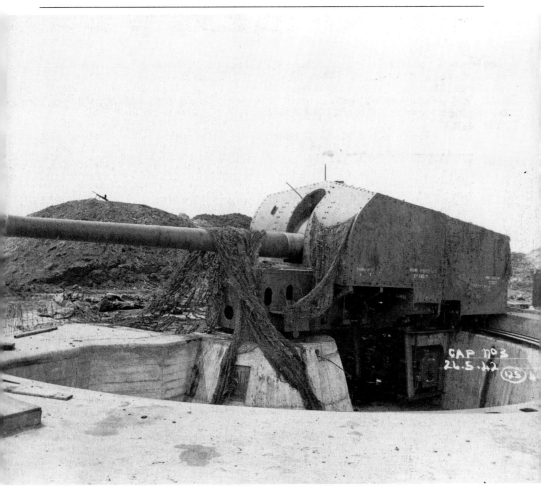

The high-angle 8 in coastal defence guns of the Capel Battery, outside Folkestone, were finally installed in May 1942. Designed to provide a flak barrage when firing in concert 'that filled the air with a curtain of shrapnel', they were first used against enemy 'E' and 'R' boats, but came into their own in 1944 when the V1 attacks started.

When a Polish Army unit, manning armoured train 'H' based at Canterbury, was disbanded it was reformed as an armoured unit, being provided with three semi-obsolete Valentine tanks. When enemy aerial reconnaissance photos suggested that there was at least one armoured unit based in the city, Canterbury was heavily bombed on the night of 31 May/1 June 1941, including their headquarters at Barton Manor.

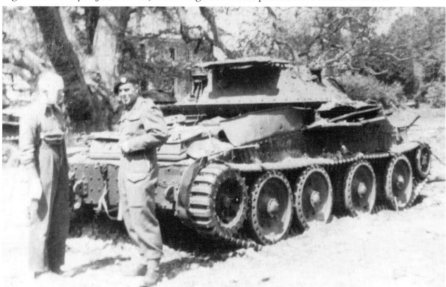

'The reason for the raid', says Joe Tomankiewicz, 'was because I took a short cut across the lawn at Barton Manor, leaving tell-tale tank tracks on the grass,' a few days before the raid occurred. All three tanks were damaged, or burnt out, including Joe's. Here, it is being inspected by a Royal Tank Corps officer, believed to be a Brigade Major from 25th Armoured Brigade HQ.

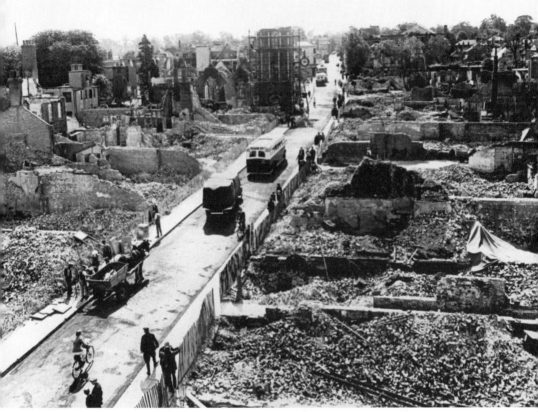

The view a few weeks later from the roof of the Marks & Spencer store in St George's Street, Canterbury, showing how all the buildings on both sides of the main thoroughfare were completely annihilated. Demolition work on the unsafe ruins has been completed, and some repaving is being undertaken by a City Council work gang with their horse-drawn wagon. A bus makes its way from a temporary bus station outside Westgate Towers, the previous site (at top right) having been one of the casualties. Apart from temporary 'pre-fab'-type shops being erected, such was the devastation that little rebuilding of the street was undertaken until after 1951.

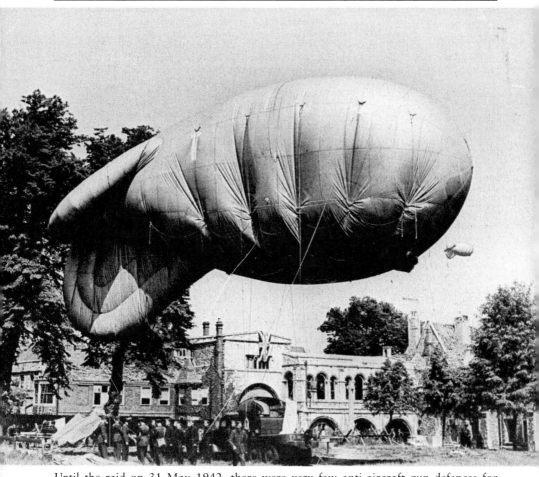

Until the raid on 31 May 1942, there were very few anti-aircraft gun defences for Canterbury, and certainly no balloons. However, after the raid barrage balloons were stationed around the city, including the precincts of the Cathedral and King's School. Anti-aircraft defences were also strengthened, with the drafting in of at least one 'Z-Battery' rocket-firing platoon. The city was attacked twice more: on 31 October by Focke-Wulf fighter-bombers, and one incendiary bomb raid in January 1944.

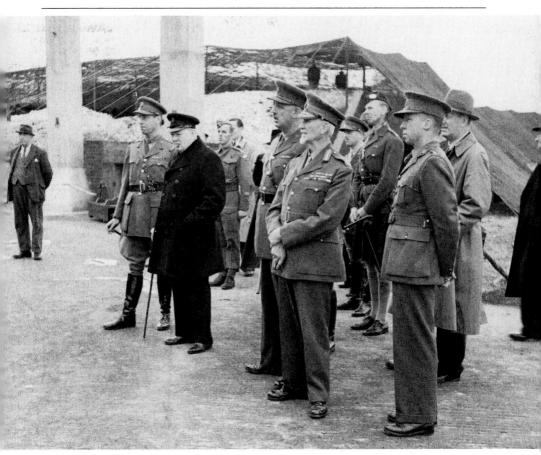

The guns at Wanstone, being our largest artillery pieces, naturally had an interest for that former naval person, the Prime Minister, and were shown to all visiting VIPs, including Field Marshal Jan Smutts, the South African Premier, and his son (on right in uniform). Mr Churchill chats to Brigadier C.W. Raw, the Corps Commander for Coastal Artillery, while on the left a rather bemused farmer wonders what has happened to his cornfield!

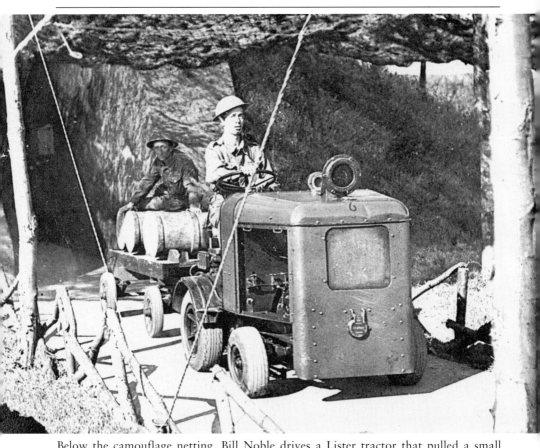

Below the camouflage netting, Bill Noble drives a Lister tractor that pulled a small trolley, loaded with cordite cartridges, from one of the two huge magazines also built at Wanstone. A network of concrete roads was provided for these little tractors in order to deliver both shells and cordite charges direct to the guns. The whole area was well camouflaged from enemy aircraft.

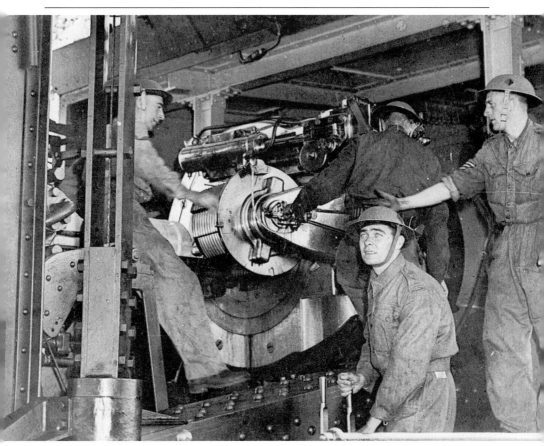

The massive breech of one of the Wanstone Battery guns is opened during a demonstration for the press. With shells weighing up to 1 cwt, loading and ramming were carried out mechanically, and movement of the guns was by electric motor. This allowed them to follow an enemy ship when it changed course, and had a vastly improved performance in comparision with *Winnie* and *Pooh* (see page 37).

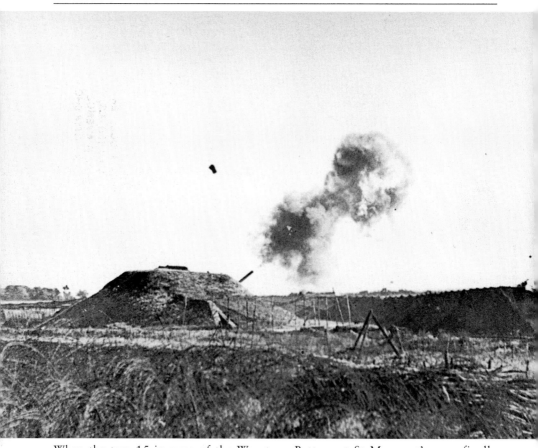

When the two 15 in guns of the Wanstone Battery at St Margaret's were finally operational in August 1942, the Royal Artillery had a means of hitting the enemy gun batteries across the Strait of Dover. Named *Jane* (after the *Daily Mirror* cartoon-strip character) and *Clem* (after the Labour leader, Mr Clement Attlee, or perhaps Mrs Clementine Churchill?), these guns bombarded both shipping and land targets, in all weather conditions, using radar plotting.

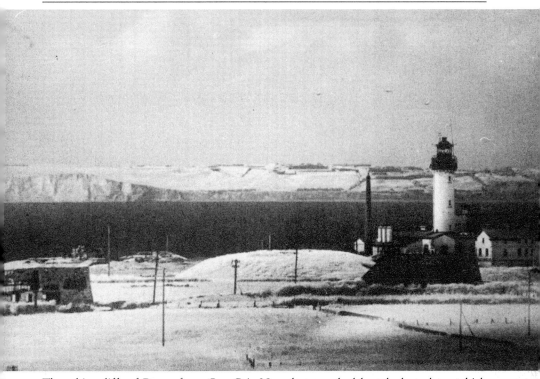

The white cliffs of Dover from Cap Griz Nez photographed by telephoto lens, which has foreshortened the view, bringing both the lighthouse and the French Dover Patrol Memorial into close proximity. The portion of the British coast visible opposite is Lydden Spout, while, to the right, can be seen the barrage balloons protecting the nineteenth-century defence works at Western Heights, Dover.

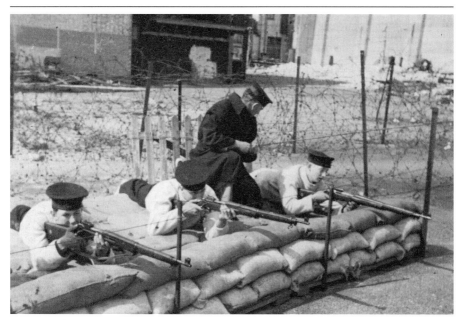

In July 1942 two of the motor gunboat crews based at Ramsgate held a shooting contest at these improvised sandbagged butts on the promenade. The team from MGB09 was beaten by that from MGB113. The latter was, left to right: 'Spud' Murphy, Freddie Gates, 'Curly' Attoe; the marker was Sub. Lt. D. Barnes (at rear). This photograph was taken by their skipper Lt. Keith Gale.

The officers and crew of Motor Launch 112 relax on deck while patrolling at speed off Ramsgate. Left to right are: Lt. Commander Fernando, Lt. Thompson, C. Horman AB. Seated aft are: B. Benson (Coxswain) and Stoker 1st Class Bill Dane. As well as minelaying and harassing enemy convoys, the craft were involved in landing commandos and scientists on enemy beaches for reconnaissance sorties leading up to D-Day.

Prince Bernhardt of the Netherlands returned to Dover harbour in 1942 when he inspected a group of fellow countrymen operating MTBs and MGBs alongside their RN and RNVR colleagues. Behind the group is the cliff tunnel through which an aerial ropeway, serving a coal saith at the end of the Eastern Arm in pre-war days, had been run.

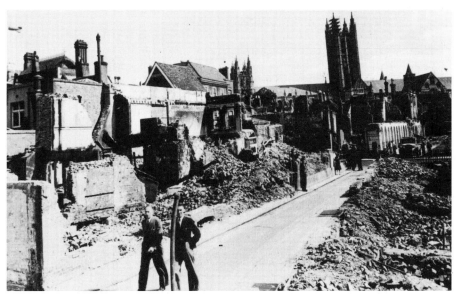

Bomb damage was gradually cleared from Canterbury's Longmarket Corn Exchange and Market Hall, before it became the site of temporary shops erected after the war. Two barrage balloons are visible (top left) and above the roof of the Cathedral (top right). After rebuilding in the 1950s in the contemporary style, this site is now occupied by some pseudo-medieval shops!

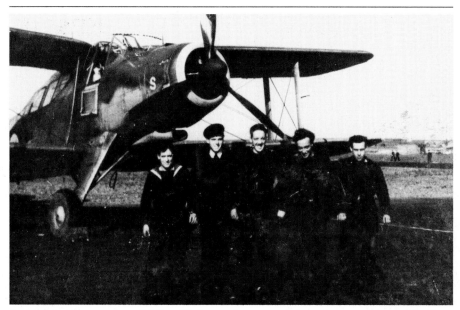

An important part of any RAF or FAA squadron was their maintenance crews that kept aircraft serviceable for flying or repaired any damage. This group of 'fitters and riggers', standing in front of one of their Albercores, served at RAF Manston with No. 841 FAA Squadron from August 1942. This was unfortunate for A/F(A) Brooks and his pals as Manston, not being a Navy establishment, did not receive a cigarette and rum ration!

A Short Stirling B1 BF325, returning from a raid on Mainz early on 13 August 1942, attempted to make a forced landing near Manston. Having successfully reached terra firma, it swung off course, rumbled into the back gardens of Nos 130–2 Rumfields Road, Broadstairs, coming to rest with it's nose against the back wall of No. 130, and collapsed on to the Anderson shelter of No. 132, trapping two children.

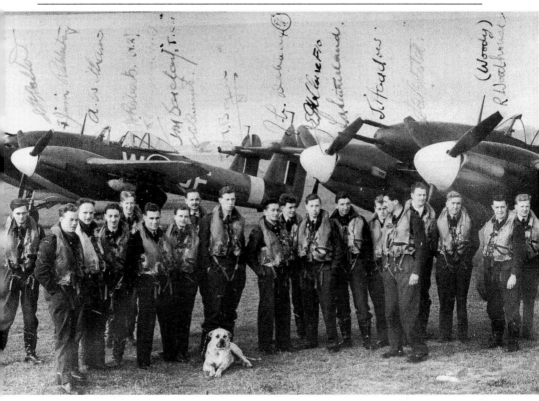

A new aircraft introduced into service was the twin-engined Westland Whirlwind, found to be more effective for attacking ground targets than for intercepting enemy aircraft. Equipped with its four 20 mm cannon in the nose, supplemented by rockets under the wings, No. 137 Squadron's Whirlwinds, based at RAF Manston from September 1942 until June 1943, proved invaluable in attacking enemy airfields, road convoys and railway traffic in preparation for D-Day.

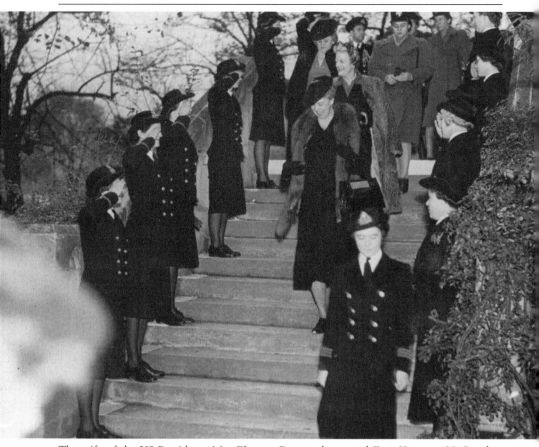

The wife of the US President, Mrs Eleanor Roosevelt, toured East Kent on 30 October 1942 and included Dover College in her itinerary as it was used as living accommodation for the Dover Wrens. Here, she is descending the steps from the main building, flanked by some of the residents and accompanied by two US Navy 'Wrens'. The party is being led by the WRNS's Chief Officer, Mrs Malschinger, sister of the stage and radio star, Leslie Henson.

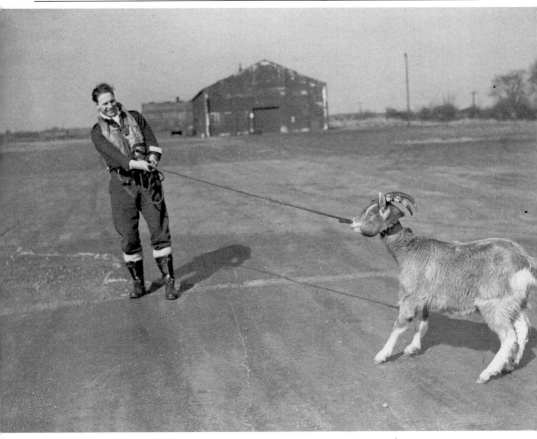

The goat mascot of No. 609 Squadron at RAF Manston is proving reluctant to get on parade. Flying Hawker Typhoon fighters, No. 609 Squadron was first posted to Manston in November 1942 to help combat the menace of Focke-Wulf 'hit and run' raiders who were bombing and machine-gunning East Kent towns. In pre-war days the area of hardstanding was originally the floor of 'X' hangar and part of the Manston railway terminus.

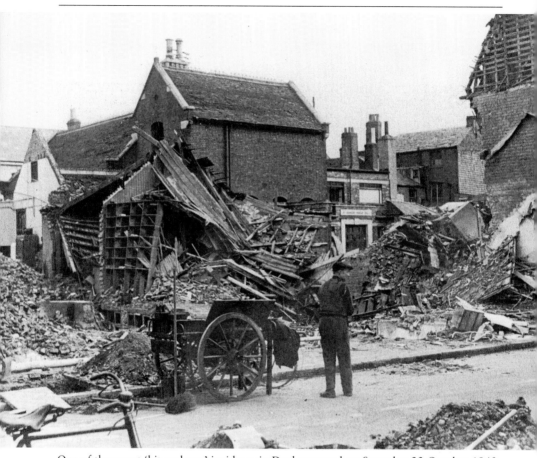

One of the worst 'hit and run' incidents in Deal occurred on Saturday 22 October 1942, when mid-morning shoppers were trapped in the High Street as bombs were dropped and hit the Gordon Blain confectionery and fruit shop, also destroying King's Bazaar, and Martin's jewellers. Among those killed was young Raymond Files, who was not immediately found; that evening a party of Betteshanger miners dug through the rubble to try to find the body of their workmate's son, but without success. As Gordon Blain's shop had a cupola on the roof, similar to both that on Deal Castle and the Royal Marine East Barracks, one might speculate it was just a tragic mistake by the enemy pilots, who had only seconds to aim their bombs before diving back to sea level to beat a retreat home.

SECTION FIVE

The Tide Begins to Turn

The invasion build-up continued throughout 1943, with the Army and Royal Marines training, and Home Guard platoons taking over a portion of their duties, including manning the coastal defence guns at Deal Castle. The enemy vessels passing through the Channel could now be attacked by the radar-controlled guns at Wanstone Farm, while those merchant ships taking passage via Dover to the Thames estuary were now afforded protection from shelling by counter-battery fire, which was directed at the enemy guns. Light Naval Craft escorted both merchant ships and RN vessels, providing smoke screens and protection against raids by enemy surface craft such as 'E' boats. Regular minesweeping had to be maintained, with losses from magnetic and accoustic mines being reduced as counter-measures became more sophisticated. The work of the RAF High Speed Launches and Walrus amphibians increased as USAAF heavy bombers joined in the air assault on the Continent, and ditching in the Channel after battle damage or shortage of fuel prevented their landing on the new emergency crash runway at RAF Manston. Civilians in the area continued to survive both air raid and shell warnings as more and more of their homes or familiar landmarks became victims of war.

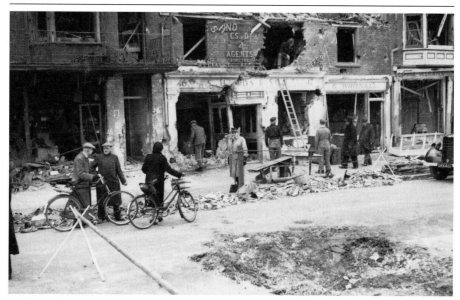

Deal, and particularly Walmer, suffered from shelling aimed at the Royal Marine depot in the town. One such landed in the roadway of The Strand, Walmer, on 2 February 1943, making an insignificant hole on the road surface, but severely damaging surrounding shops. These included Snow's (newsagent), Hinds (auctioneers) and Boothby (butchers), where some Council workmen are starting to clear up.

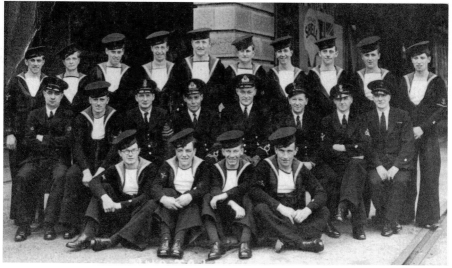

The crew of HMS *Taipo* (Maori for *Black Devil*) on the Admiralty Pier, Dover, where they were based while on minesweeping duties in 1943. Signalman Joe Drew recalls that they had an emergency call to sweep some 100 mines laid by 'E' boats on one occasion. So happy was Joe in his work that he arranged a transfer to HMT *Maratta* when the *Taipo* was due to be moved away from Dover.

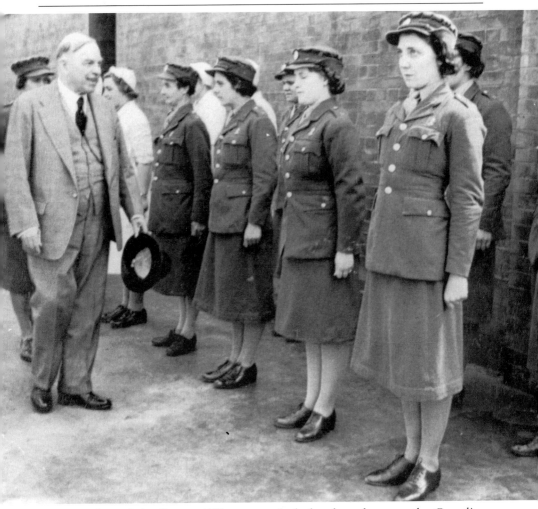

One member of the Dover ATS was particularly pleased to see the Canadian ambassador as he was from her native land. Joyce Elkington (in the front row) stands smartly to attention awaiting her turn, when the ambassador did, indeed, pause to have a short chat with her. At the far end are three ATS cooks, including Mrs (Sgt.) Gallop who, with her mother also a cook, had joined the local ATS regiment in pre-war days.

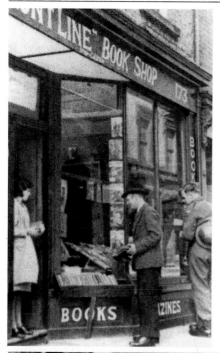

Proof that life went on in Dover, despite bombing and shelling, was the aptly named Front Line Book Shop in Dover's Snargate Street. Like the Windmill Theatre in London, the bookshop never closed during the entire five years of war. A Royal Artillery Sgt. (right) looks for a book to read during brief snatches of time off duty, while the civilian wants something to while away the hours spent in his shelter or in the Dover Caves.

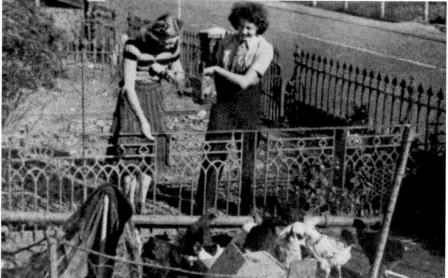

The gardens of houses on Dover seafront were turned into production areas for growing crops, or for keeping chickens to supplement the meagre and infrequent egg ration. My late mother-in-law's sister sent her a couple of hens by rail from Northumberland to Deal, and by the time the crate arrived one hen had already laid an egg. My mother-in-law also churned cream from the milk each day to provide butter for their teas.

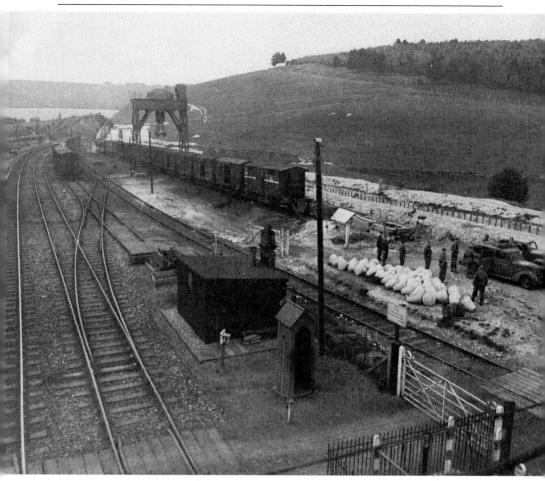

The gun park for the Royal Marine Siege Regiment at St Margaret's was at Lydden, on the Dover–Canterbury railway line. Their living accommodation was in the converted box vans parked on the sidings (centre) and an overhead gantry was used for changing the barrels of their 13.5 in mobile railway guns. Access to the site was barred to the public by a sentry box and a WD 'No Entry' notice (in the foreground), while anti-tank 'pimples' in the background were kept ready to block the crossing to enemy tanks. It may well have been an inspection day, judging by the staff cars parked in the background (right).

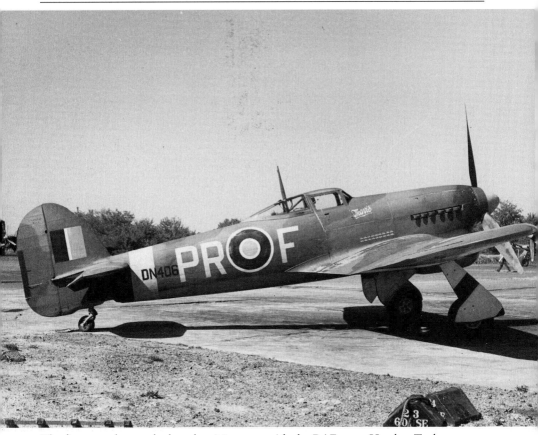

The first squadron to be based at Manston, with the RAFs new Hawker Typhoon, was No. 609, which had arrived in November 1942, staying until June 1943. Despite some initial teething problems (an under-developed engine and a tailplane which snapped off in a dive) the Hawker Typhoon was eventually a very efficient fighter and ground-attack aircraft. It was used initially to combat the Focke-Wulf FW190 'hit and run' raiders. No. 609 Squadron returned to Manston in December 1943 for another six months for 'softening up' operations on enemy defences prior to the D-Day invasion.

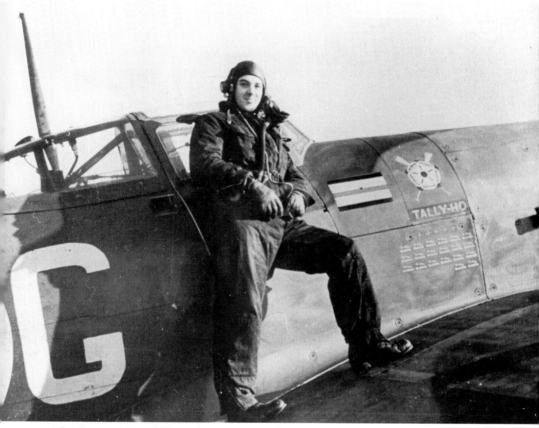

The Commanding Officer of No. 609 Squadron during its initial stay at RAF Manston was Sqn. Ldr. R.P. 'Bea' Beamont. His personal Typhoon Mk 1a (car-door-type cockpit entry) carried the white rose of York on the cowling together with his personal scoreboard of some seven enemy aircraft and twenty railway locomotives, shot down while on long-range sorties over France. A firm supporter of this aircraft Bea had introduced 'loco-busting' to the squadron while at Manston, and he remained with them until June 1943.

On the Lees at Folkestone, this well-camouflaged look-out post commanded a view over the sea towards Boulogne. Attempts to brighten it up included acquiring a bench seat and a small flower bed. To the right is the harbour breakwater, while below is the truncated stem of the old Victorian Pleasure Pier, breached in the summer of 1940 to dissuade an enemy who might be tempted to stage a landing.

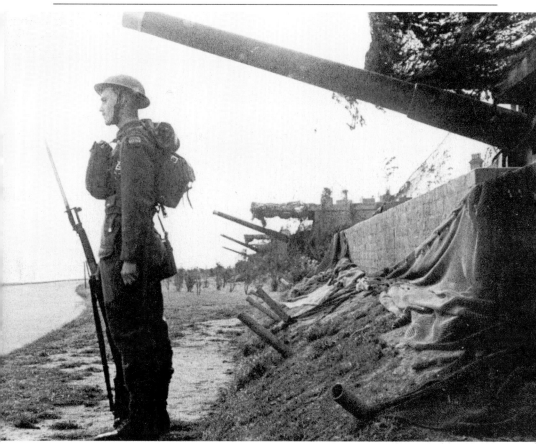

Positioned on the famous Lees at Folkestone, Mill Point's four 5.5 in guns had been removed from HMS *Hood*, and guarded the western side of Folkestone harbour. The guard is a member of the Coast Artillery, now part of 12 Corps (commanded by the then General Bernard Montgomery), indicated by his shoulder flash depicting the oak, the ash and the thorn. It was at Mill Point that Ted Greenstreet recalls seeing their Sergeant Major's boots catch alight when he stamped his feet over enthusiastically on a petrol-soaked promenade one Sunday morning!

By 1943 the neglected Lees at Folkestone had succumbed to nature, and grass and even small trees had overrun those once-manicured lawns on the clifftop that were so well remembered by pre-war visitors to the town. This Battery Observation Post served the Mill Point Battery and was well protected by camouflage and netting. The men approaching it are not elderly Boy Scouts, but some of the Canadian troops that were based in the town.

By 1941 No. 160 Railway Construction Company, Royal Engineers, had taken over the Romney, Hythe & Dymchurch Light Railway, operating the service of leave trains for troops based on The Marsh along the 15 in gauge line, which remained in place until late 1943. Here, four members of a track maintenance gang, two of them using shovels that are marked RHDLR, were photographed near to Greatstone.

Midday on Saturday and nary a soul in sight! A deserted Sandgate Road in Folkestone pays witness to the effectiveness of the evacuation that civilians undertook in 1940. Of the pedestrians seen here the military personnel outnumber civilians by three to one. Horse power delivers the milk (right), while an Auxiliary (now National) Fire Serviceman starts a queue of one for the next showing of *The Life and Death of Colonel Blimp* outside the cinema.

For those USAAF aircraft which force-landed around Romney Marsh, Sgt. Bill Holdcroft and the members of his 16th Mobile Recovery Unit were nominally based at Lympne, but they also had a transport yard at West Hythe to save the long climb up the escarpment each time they returned home. The unit visited all US aircraft crashes and carried out repairs where possible, and if not, transported them to Manston to be dealt with there. Here Bill and a colleague have cycled to Hythe for a day of sightseeing.

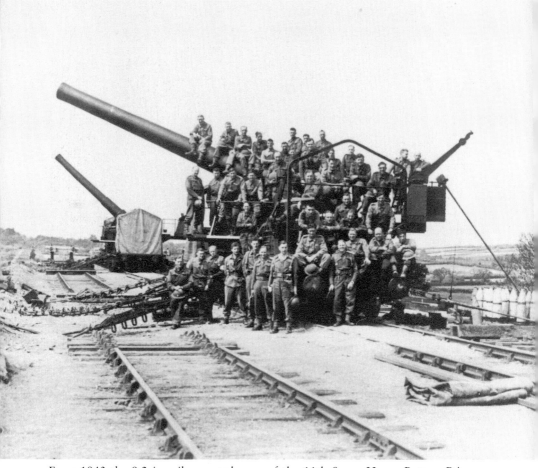

From 1943 the 9.2 in rail-mounted guns of the 11th Super Heavy Battery RA were based at Bargrove Wood, between Folkestone and Sandling on the Ashford line. With S.M. Cleeve and E.E. Gee on brass plaques attached to their mountings, these were the only guns of their type to be named. It was one of these guns, E.E. Gee, that fired a round towards a flotilla of 'E' boats off Folkestone in July 1940, before being dismounted by the recoil. This was the only time that these railway guns saw action.

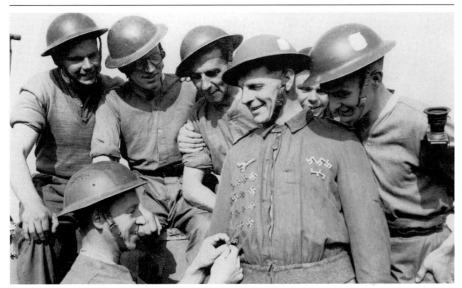

Gunners of 339 A/A Battery at Don 1, on Dover's Western Heights, obtained this souvenir – a flying jacket – from one of their victims. Every time an enemy aircraft was shot down another Swastika was added. Note that unit flashes on their helmets have been painted out by a censor before photographs were released; and that over the previous four years the numbering of local A/A sites had altered.

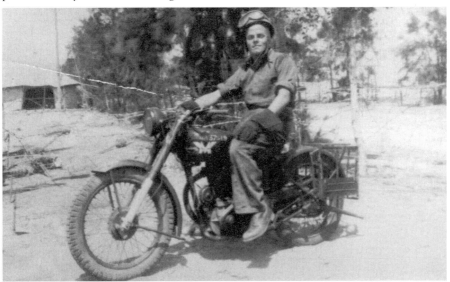

Bob Mcpherson served with No. 131 Despatch Rider Section, Royal Signals, based at Orpington, but was attached to No. 144 Division at Dover, collecting messages from Dover Castle and delivering them to the War Office in London prior to D-Day. This gave him an opportunity to visit his girlfriend at Farnborough, North Kent, en route. Here, he is seen sitting astride his beloved 500 cc Matchless motorcycle.

Being a local girl, May Pridmore joined her local 42nd ATS Regiment in 1938 and went on to serve at the Armaments Office at Langdon Battery, as well as in the CARA Plotting Room under Dover Castle. During the Sports Day, held at Fan Bay Battery on 25 September 1943, the battery mascot 'Gunner' took a fancy to her, as did her future husband Jack who was serving there at the time.

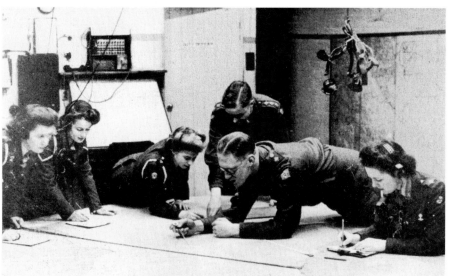

Along with other local girls, May Pridmore plotted targets for the RA on this plotting table in the tunnels under Dover Castle. In the background is the telephone switchboard, while on the side wall (right) is the local area map, and spare telephone headsets hang from the ceiling. Lt. Col. Lindsay leans on the table to check a plot, and Capt. Fox, an Instructor in Gunnery, checks a map reference.

Serving at Dover with their Royal Navy comrades were these members of the Royal Norwegian Navy, photographed outside the Light Coastal Force headquarters at HMS *Wasp*. Commanding Officer of 11th Flotilla, Commander Weir (three rings on cap) sits next to the skipper of MTB72, Lt. Kingchurch is in the second row of officers, while Ray Floyd and his crew are among the ratings in white sweaters. The Norwegians can be identified by their different style of caps.

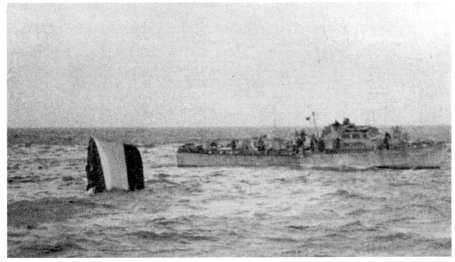

The bows of ML108 disappear below the waves off Folkestone, after she was damaged off the French coast in September 1943. Taken in tow by the Staff Officer of the 50th ML Flotilla, it was well after dawn before she eventually sank, some 5–6 miles off shore. First Lt. Jeffries had been given command of her some nine months previously to engage in minelaying and the landing of RM commandos by canoe.

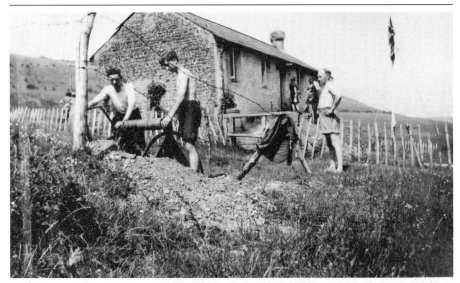

With so many Dover Scouts, Sea Scouts and Guides evacuated, the troops amalgamated their remaining membership into The Hellfire Patrol, consisting mainly of senior Rover Scouts and Ranger Guides. Sea Scout Skipper 'Sticky' Wickham (right) watches while Joe Harman and Frank Young haul water from the well at Hellfire Cottage in Elms Vale, which was some way out of town and relatively safe.

The purchase of Hellfire Cottage was instigated by Kath Godfrey, and became a safe haven from the dangers in Dover, as well as a meeting place for Scouts and Guides or their colleagues serving in HM forces in the area. Frank Young, seen in Sea Scout uniform, also served as an ARP messenger, necessitating many a hurried dash on his bicycle back to his Z1 Warden Post on the seafront whenever the air-raid siren sounded.

SECTION SIX

Invasion and Buzz Bombs

The singular lack of success of the Luftwaffe's mini-blitz over the winter months of 1943–4 had turned their attention to other ways of trying to subdue the citizens of London. Photo reconnaissance and the heroic efforts by both Resistance workers on the Continent and agents within Germany had alerted the Allies to Hitler's secret weapons that were to be unleashed on Britain. Steps to prevent, or at least slow down, both production of these weapons and construction of installations for both V1 pilotless planes and V2 rockets occupied both the RAF and the USAAF in the months leading up to D-Day. The Army's deception operation reached top gear with the construction of dummy landing craft to be anchored in harbours along the south and east coasts, including both Dover and Folkestone, while at Richborough Port concrete units for the Mulberry artificial harbours were constructed and hidden. The Navy's minesweeping operations increased apace as D-Day approached, keeping the sea lanes clear to facilitate re-supply of the invasion forces, and to clear German mines blocking the approach to the Normandy beaches.

By January 1944 German air raids had been reduced to the occasional sorties by Focke-Wulf FW190 fighter-bombers, which were often caught by radar-equipped night-fighters, or shot down by ack-ack fire. This FW190 was one of the victims of the Dover ack-ack. It crashed at Oxney Court, on the Deal to Dover road, late in the evening of 2 January 1944. Although the pilot baled out, he was blown out to sea and probably drowned.

On 6 January 1944 Muriel Sidwells married Lawrence Golding at St Andrew's, Buckland, by the rector for whom she had worked earlier in her career. 'I borrowed my dress, but made the dresses for both the older two bridesmaids.' Due to strict security regulations, many guests from outside the area had difficulty in attending, needing special passes to enter the coastal area around Dover.

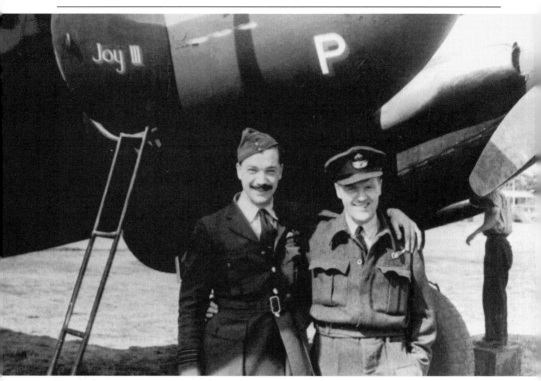

Based at Manston during 1944 with No. 605 Mosquito Squadron were Sqn. Ldr. K.M. Carver (o/c 'B' Flight) and Flt. Lt. Jack Bignell his navigator. The Mosquitoes struck at many targets in France, as part of the build-up for D-Day, as well as supply routes and transport associated with the V-weapons. During the flying bomb attacks from June to September the night-fighter Mosquitoes patrolled off the coast to shoot down incoming V1s.

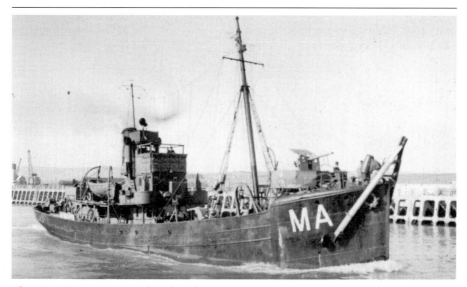

The *Maratta* was equipped with a device similar to a kango hammer, mounted on her bows, which could detonate acoustic mines by sending out sound-waves when lowered into the water. Joe Drew remembers that prior to D-Day they spent many weeks anchored off Dungeness in an attempt trying to sweep a clear passage to the Varne Bank without the Germans discovering what they were doing.

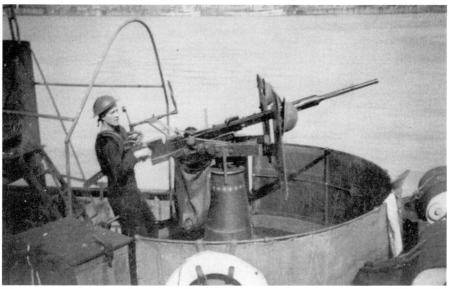

The minesweeping trawlers carried out extensive sweeping operations in the weeks leading up to D-Day. On assembling at Dover one flotilla had the dubious honour of leading the battleships bombarding beaches prior to the invasion fleet landing. Alongside the Prince of Wales Pier in Dover harbour, Gunner Danny Byrne mans his Oerlikon gun to defend HMT *Maratta* from enemy attack.

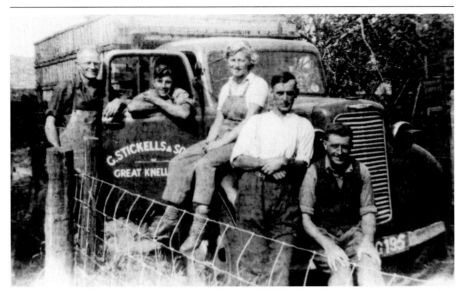

The Stickells family owned Great and Little Knell Farms, Westmarsh, and their farm truck was used to deliver vegetables and fruit to markets in Sandwich or to Covent Garden in London. Some of the workers were, left to right: Arthur Fisher, Bill Bailey, Connie ?, farm foreman (?), Dick Powell. When WLA girls lived-in at a farm it was pure chance whether they lived well or were given minimum rations.

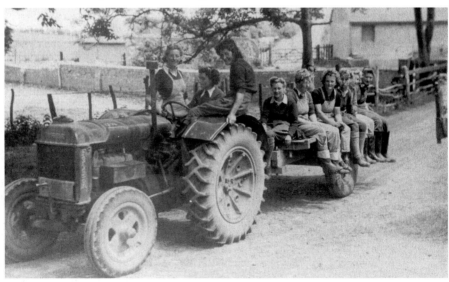

Land Girls working at Beer farms at St Margaret's were in range of the German guns and had to dodge both bombs and shells on occasions. Here a group arrive back after a hard day's work. On tractor: Grace Harrison (later Mrs Guest), Joyce Twyman, Marjorie Curling (driver). On trailer: Florrie Bell, Nancy ? (from Birmingham), Margaret Robinson, Winnie Drew, Mary Evans (later Mrs Guy), Mary Rogers.

Field Marshal Erwin Rommel had taken charge of the Atlantic Wall in December 1943, the same time General Eisenhower had been appointed as Supreme Allied Commander for Overlord. Rommel (front left) is on his inspection tour of the French coastal defences at Batterie Todt, with Captain Kurt Schilling, Commander of the cross-Channel gun batteries in the Pas de Calais area.

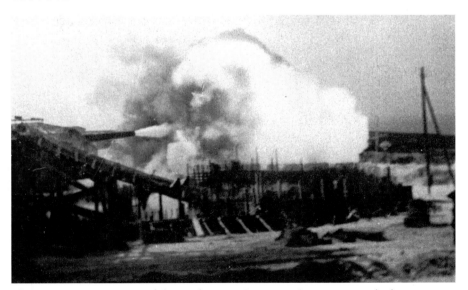

The 406 mm (16 in) guns of the Lindermann Battery at Sangatte were the largest cross-Channel guns used to bombard East Kent. Housed in steel barbettes and surrounded by tons of concrete, only a direct hit would knock them out. In the weeks leading up to their capture by the Canadian troops, the four batteries of German guns fired many salvoes into Dover, Folkestone and Deal.

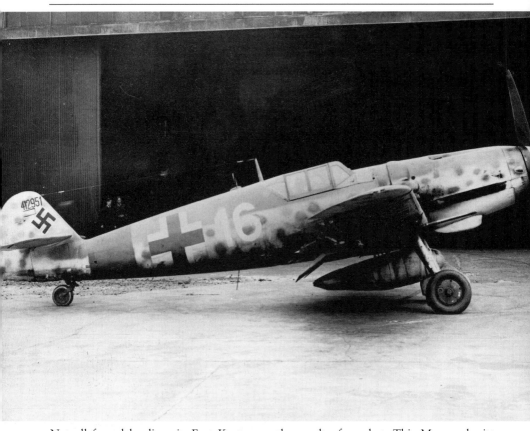

Not all forced landings in East Kent were the result of combat. This Messerschmitt Bf109G-6 (No. 412951) was one of two which ran out of fuel and were forced to land at Manston on 20 July 1944. Another Bf109 is supposed to have deliberately crash-landed near Margate by its defecting pilot; while two Dutchmen flew their Fokker seaplane over to Thanet and landed at Broadstairs, and a Frenchman arrived in his Caudron Geoland transport on the beach near Dungeness.

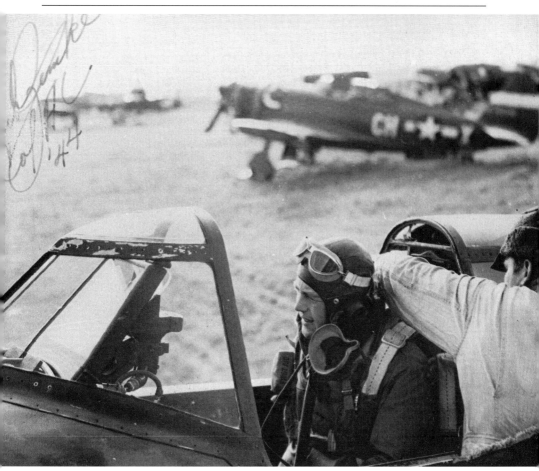

Sgt. Bill Holdsworth adjusts the safety harness for Col. Hubert 'Hub' Zemke, Commanding Officer of the 365th Fighter Squadron, while waiting to take off from RAF Manston in his Republic P-47C Thunderbolt. Bill was now with a service crew which refuelled, rearmed or repaired USAAF fighters that landed there during the summer of 1944. Col. Zemke was so pleased with the service he received at Manston, he signed this photograph (top left) for Bill.

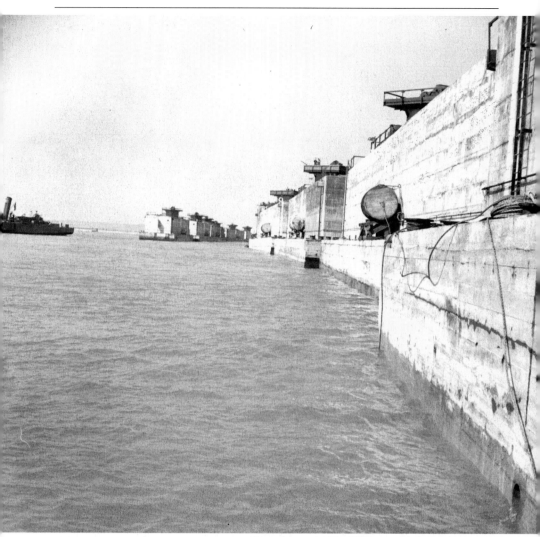

Sections of the Mulberry artificial harbour were towed past Dover on the morning after D-Day, much to the surprise of troops watching on the clifftops, who logged them as bridge sections. When bad weather blew up, some units were anchored in Dungeness Bay off Greatstone. A few were holed but were quickly repaired by gangs of Irish building workers who rushed down to the area.

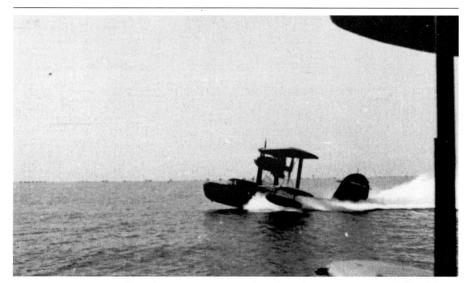

An Air-Sea Rescue Walrus, from No. 227 Squadron based at Hawkinge, taking off from Dungeness Bay; some Mulberry harbour units are anchored in the background. Due to its distinctive engine note, one Walrus flying off the coast in mist was mistaken for a V1 by ack-ack gunners and it was fired upon. Wireless Operator Ernest Cartwright recalls, 'when we realized what was happening we beat a hasty retreat!'

During the build up to D-Day some US Navy signalmen joined Wrens in the communications complex under Dover Castle, as part of the Bodyguard deception scheme. On the cliffside ledge in front of the Calais View Canteen (the Nissen hut in the background) they were able to watch the V1 launches by day, or at night when it looked like a fireworks display on the French coast.

Members of the American Ack-Ack Corps based at Kingsdown, near Deal, had a novel way of celebrating the invasion. Confined to their camp after being briefed of forthcoming events they all decided to improve their grooming before landing on the beaches. The legend on the blackboard reads 'D-Day Haircuts – special sale D-Day cuts one shilling – bring your own razor'.

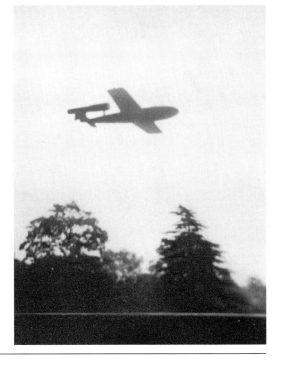

Only a week after the successful landings in Normandy, East Kent heard and saw the doodle-bugs clattering over the coast heading for London from launching sites in the Pas de Calais. Fortunately only a few were shot down over the area but when they did land the results caused some deaths and injuries. At Littlebourne on the night of 4 August the casualties included the wife of the local doctor.

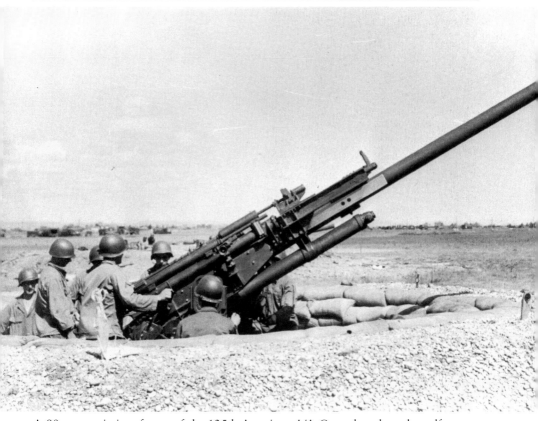

A 90 mm anti-aircraft gun of the 125th American A/A Corps based on the golf course at St Mary's Bay, near New Romney, well dug into the beach. As well as Royal Artillery and RAF Regiment anti-aircraft batteries, the AAA shot down hundreds of V1s off the coast of East Kent when guns stood almost wheel to wheel from Dungeness to North Foreland in the summer of 1944.

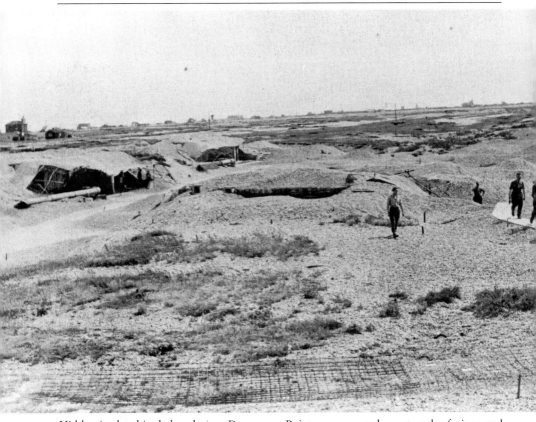

Hidden in the shingle beach near Dungeness Point was a complex network of pipes and control valves, while some seaside bungalows nearby had been converted into pump-houses. From Dungeness fuel was pumped across the Channel to France by a submarine pipeline, laid down from giant cable drums that were towed by tugs. Under the code name of 'Pluto' this pipeline was one of four planned to supply the Allied forces as they advanced from the Normandy beach-head. It linked the system of pipelines which originated at the Shell oil refinery installation at Ellesmere Port, Cheshire.

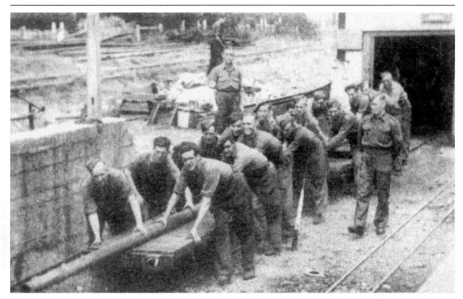

Sections of the pipework for 'Pluto' were delivered to New Romney main line station and thence, by a special spur line, to the Romney, Hythe & Dymchurch Light Railway engine shed where they were welded up into long lengths. Using the Light Railway's wagons they were then dragged down to Dungeness, causing considerable damage to the track which had to be repaired after the war, thus delaying the re-opening of the line.

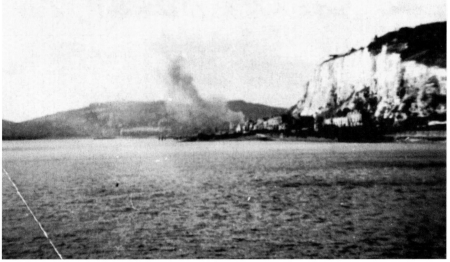

What is claimed as the photograph of the last shell to fall on Dover was taken from the Eastern Arm of the harbour on 27 September 1944, showing the eruption of dust and debris from an area of the town near Snargate Street. It was there that one of the last shells fell on the Salvation Army Red Shield Club Canteen, exploding in the basement and causing damage and much loss of life.

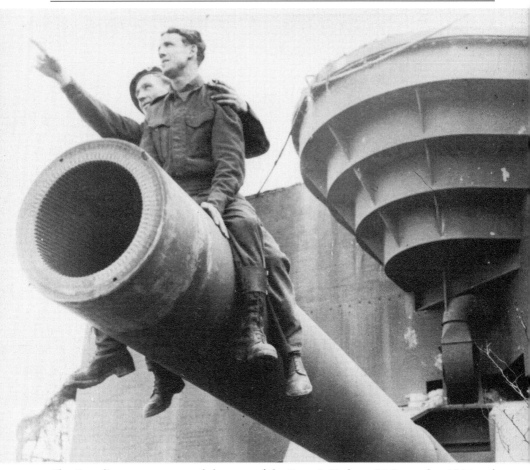

The Canadian troops captured the guns of the Batterie Todt on 30 September 1944 and the shelling of East Kent was finally ended. Here, two of the victorous Canadians sit astride the barrel of one of the 280 cm (11 in) guns that were housed in vast concrete gun shelters. The greater fire power of the German guns was never matched by those at Dover, and they caused much damage and loss of life in the coastal towns during a bombardment that started in August 1940.

When they heard the first siren, old hands in Dover, who remembered the First World War, headed for the safest haven from falling bombs – the Dover Caves. For the next five years they became a home from home for many, from the oldest to the youngest. Nurses from Buckland Hospital, including Mrs Gwendoline Curd, regularly visited to check on the health of the occupants, while youngsters from Buckland Youth Club Choir, including Muriel Sidwells, sang to the troglodytes. In fact, when the shelling ended, many were reluctant to return to homes battered by bombs and shells.

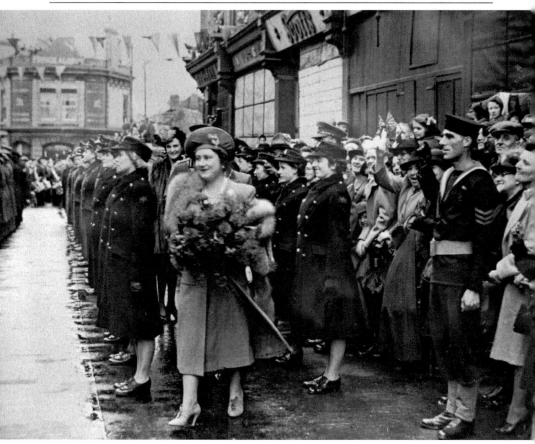

Both King George VI and Queen Elizabeth visited Dover on 18 October 1944, when the end of shelling made it safe for them to do so. After touring various places around the town they inspected a representative group from the Armed Services and civilian organizations outside the Maison Dieu Hall in Biggin Street. Here, Her Majesty The Queen passes along the ranks of the Women's Auxilliary Fire Service, watched by the excited crowds of happy local residents and their children.

Victory and the Aftermath

With the end of the shelling of Dover and other coastal towns the life of local residents returned to something like normality. Children could return from Wales (some had been brought back already), schools re-opened, if not too badly damaged, and in the shops, despite continued rationing and shortages, toys and some sweets started to reappear. The vast Army camped in East Kent had all gone, likewise the anti-aircraft guns and searchlights, which had been drafted into the area to combat the V1s the previous summer. In Dover a Royal Navy presence continued, although it was mainly minesweepers in the harbour rather than warships. As the Allied armies advanced along the coast of France, ports such as Calais and Boulogne were liberated, and supplies were delivered from Dover and Folkestone, while US ambulance trains and rail locomotives were returned via modified train ferries. The air battles now took place far away, but fighters escorting Allied bombers still used the East Kent airfields until the final victory.

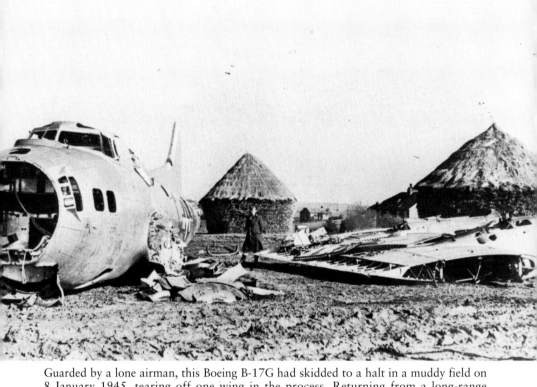

Guarded by a lone airman, this Boeing B-17G had skidded to a halt in a muddy field on 8 January 1945, tearing off one wing in the process. Returning from a long-range mission over Germany it must have been out of fuel or the straw stacks of Westcliffe Farm, between St Margaret's-at-Cliffe and Dover (seen in the distance), probably would have been set alight. Since the Battle of Britain farmers in East Kent had become accustomed to finding badly damaged, or burnt-out aircraft crashed in their fields and took subsequent loss of crops as a matter of course.

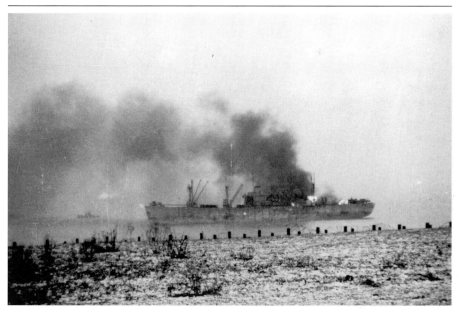

Liberty ship *James Harold* was towed inshore following a collision and fire. She was beached at Kingsdown, subsequently refloated and then grounded on the Malmes Rocks, near Deal Castle. Loaded with aviation fuel, she burned with a spectacular ferocity. Jerrycans of petrol were salvaged and taken to sidings at Walmer station, but a carelessly discarded cigarette caused an explosion, killing six US soldiers.

Part of the important work of the Admiralty tugs was salvaging the damaged and stranded shipping on the Strait of Dover and, within Dover harbour, clearing blocked ships and fairways. Viewed from Admiralty Pier, the tug in the foreground appears to be *WCII*, while that tied up at the Prince of Wales Pier (background) is a Dover harbour board tug.

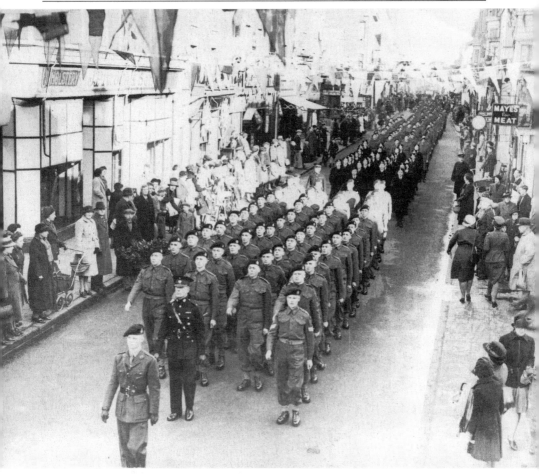

The Royal Marines were granted the Freedom of Deal at a ceremony held on 14 February 1945, which included a march-past through the town, so flags and bunting, last used for the 1937 coronation, decorated the town. Citizens lined the streets in the sunshine when this contingent of Royal Marines and Wrens marched down the High Street passing shops still boarded up or suffering from bomb or shell damage. However, two WAAFs from RAF Hawksdown (right) ignored the spectacle.

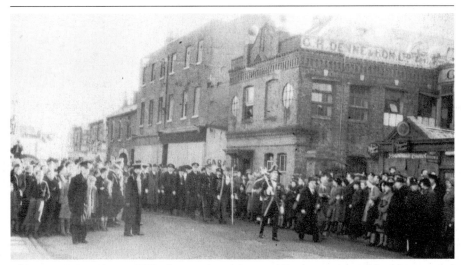

Alderman E.J. Dobson, OBE, the wartime Mayor of Deal, together with aldermen and councillors of the Borough Council and VIPs are led by Town Sergeant Phillpot up Queen Street towards the Odeon Cinema, where the Freedom Scroll will be presented to the Deal Royal Marine depot Commandant. Denne's builder's yard on the right was owned by one of the councillors, Mr Lionel Denne.

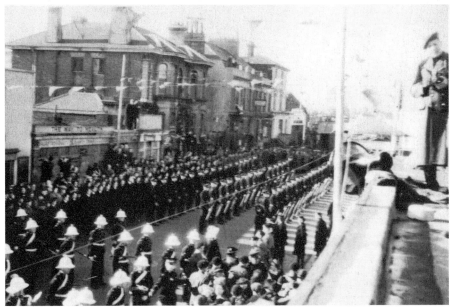

The parade photographed from the roof of the cinema, with Chatham Division Royal Marine Band, Casket Escort and the contingent of Wrens drawn up before it. Every vantage point was taken by spectators, including my own family who were standing on the opposite side of the road. To the left is Mr Lionel Denne's former residence Neville House, later occupied by the Borough Surveyor's and Town Clerk's departments.

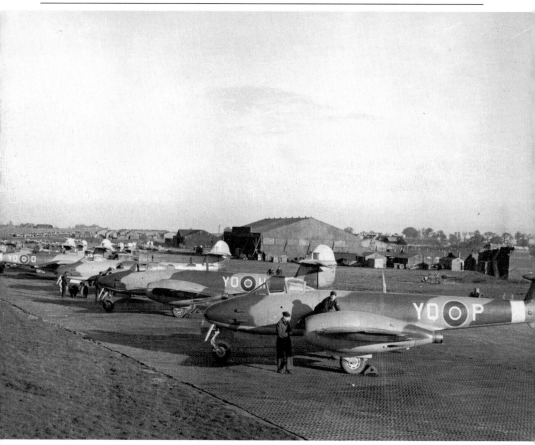

In June 1944 these Gloster Meteor F1 jet-fighters at RAF Manston were just 'working-up' with No. 616 Squadron when they were needed urgently in East Kent to intercept the V1 flying bombs. As the jet-engines scorched the grass runways, PSP (Perforated Steel Plank) was laid at hard standings, and at their dispersal airfield at High Halden near Ashford (a necessity due to their limited range). However, Meteors could match the flying bombs in level flight, and the pilots of Meteors developed a technique of toppling the V1s over with their wing-tips. In April 1945 they were still at Manston.

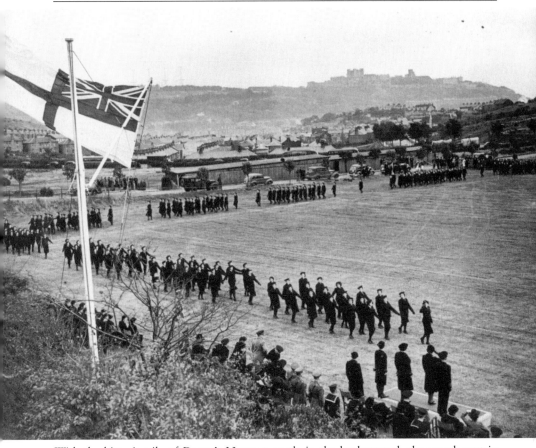

With the historic pile of Dover's Norman castle in the background, the march-past in early 1945 for the visit of HRH Princess Marina, Duchess of Kent, at the Boys County School, Dover, had an impressive setting. As it had been one of the accommodation sites for the Dover Wrens, it was most apt that this was the site of their parade. A few civilians also gathered behind the fence (background left), while the buses which brought Wrens from other locations were parked along Astor Avenue.

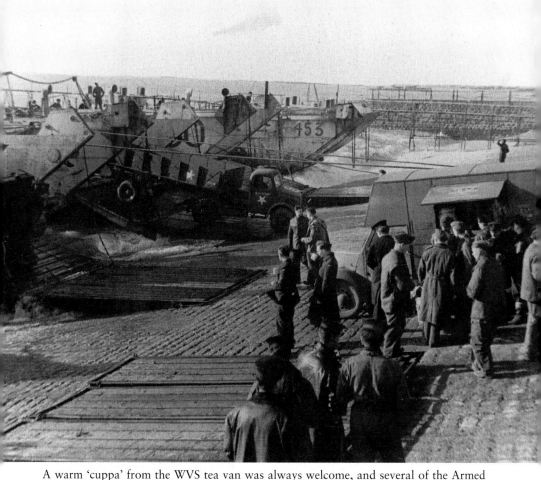

A warm 'cuppa' from the WVS tea van was always welcome, and several of the Armed Services are represented in this group on one of the Dover harbour 'hards'. Although the D-Day invasion was not mounted from East Kent, support for the Allied troops in France during their advance was undertaken from the local ports, hence the landing craft present. The wreck of HMS *Codrington* is visible in the background.

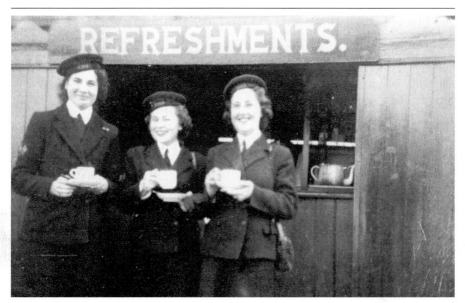

The snack bar outside HMS *Wasp*, in Lord Warden Square, was one of the features of wartime Dover, and was owned by a well-known character. It provided both service personnel and civilians alike a much appreciated refreshment. Despite the reputation that the tea tasted as if it had been stewing for weeks, Wrens Toni, Isobel and Barbie drink their well-earned 'cuppas' after coming off duty.

This impressive view of Dover harbour was photographed by Wren Joyce Atkins (later Mrs Atkinson) from the balcony leading off Vice-Admiral Ramsay's complex in the casemates under Dover Castle. It shows the old seaplane shed, used by the Royal Naval Air Service during the First World War, the rusting beached wreck of HMS *Codrington* (background), the Prince of Wales Pier (top left), and two small oil tankers anchored in the harbour.

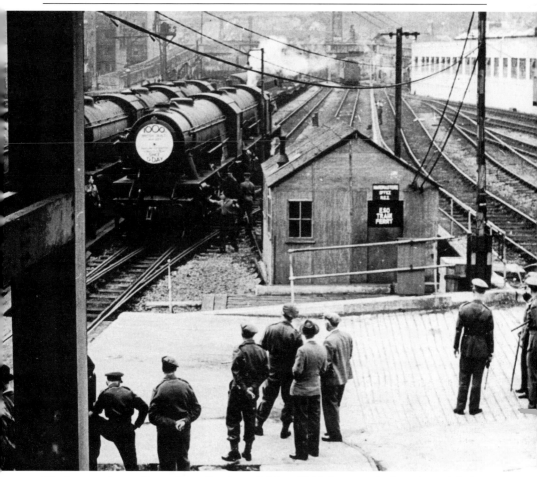

The locomotive at Dover Ferry Dock on 9 May 1945, bears a signboard proclaiming '1000th British-built locomotive shipped to the Continent since D-Day' (though not necessarily via Dover). The two civilians and some Army personnel watch the loading on to one of the ex-Southern Railway train ferries. Loading could be done without using the portable ramp at Dover which saved time, although locomotives and road vehicles had to reverse off at Calais as the ferries were not roll-on/roll-off vessels.

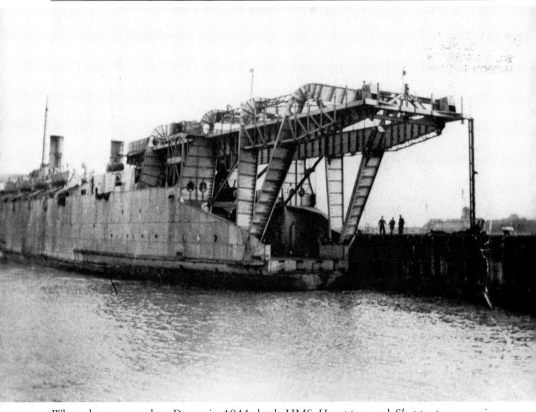

When they returned to Dover in 1944, both HMS *Hampton* and *Shepperton* were in very different guises, having had a large gantry erected above their superstructure aft. Fearing that all French port facilities, and especially any railway berths, would have been sabotaged, the Army had decreed that these train ferries should be capable of discharging locomotives on purpose-built hards with rail connections at any of the Channel ports. By 1945 both vessels were being used to return railway locomotives and also road vehicles to Dover, where the Ferry Dock had remained intact.

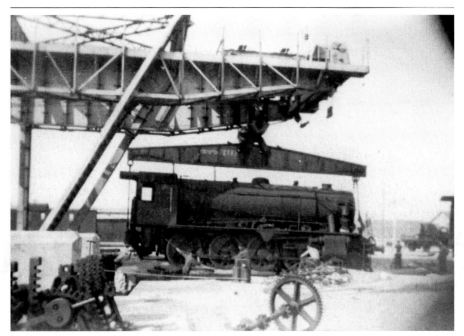

The gantries on the two train ferries carried a dismountable platform which could be used as a bridge between vessel and shore; some of the heaviest loads handled included these American-built 0–8–0 utility locomotives of the US Army Transportation Corps. The uncleared debris of the original dock installations and German harbour defences at Calais are still visible on the quayside.

A group from one of the loading gangs working aboard HMS *Hampton* in 1945 included, left to right: -?-, ? Higgins, Tom Phillpot, ? Burgess, Ernie Dixon, with young Dennis Beecham squatting in front. These handling crews were split into 'A' and 'B' shifts working turn and turn about. After his return to civilian employment, Ernie Dixon served with British Rail and Sealink, retiring with the rank of Bosun.

Throughout the war women took over when men were either conscripted or volunteered for the Services. This group of clippies, employed by the East Kent Road Car Co. at their Deal garage, had vowed to keep in touch. 'During the black out you got to know every bump in the road, so you could announce each stop for the passengers', recalls Marjorie Fenn. On more than one occasion buses were machine-gunned by marauding Messerschmitts.

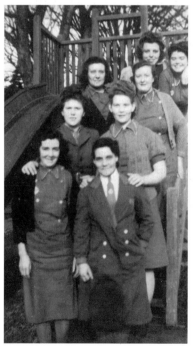

When they were bombed out of their building at RAF Lympne, these NAAFI girls had been transferred to the local village. 'There are the girls outside the village hall', wrote Irene Shaw. 'Me at the top on the left with Heather from London; Monique and Maud – the two Irish girls; Myrtle and Muriel; Gladys and Mrs Richardson – the manageress.'

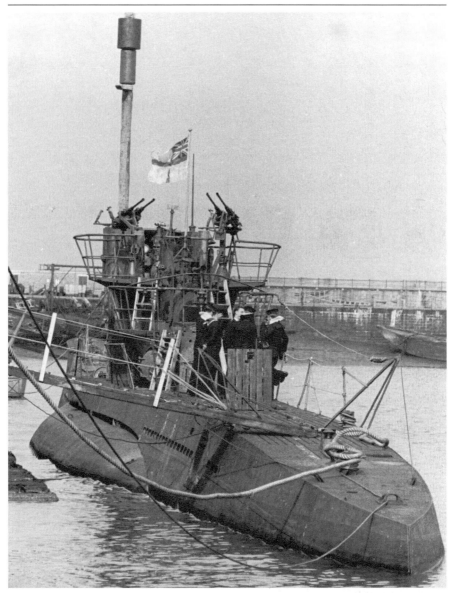

'The Enemy Comes to Dover.' This German U-boat U-277, flying the white ensign, is in the Camber while on its way to be scrapped. Her tall snorkel tube, enabling the submarine to run below the surface while recharging her batteries, is prominent. A group of British tars are on the foredeck waiting to descend through the open hatch to view the interior. Although no U-boats were reported having attempted to enter Dover harbour, at least one Royal Engineer claims that he fired on one lurking off the Eastern Arm.

Acknowledgements

I would like to thank the following for the loan of photographs:

Mrs G. Anderson/Syd Goodsell Collection
Colonel B.E. Arnold • Mr Ted Ashton • Mrs Joyce Atkinson
Wg/Cmdr. R.P. Beamont DSO, DFC • Mr Stan Blacker/RM Museum
Tony Blake Collection • Mr R.S. Body • Mrs M. Bower • Mr R.V. Brooks
Mr Eric Bull • Mrs M. Burgess • Mr E.H. Cartwright • Mr Norman Cavell
Mrs Lilian Clark • Mr Les Cooper • Mrs L. Crowther
Mr Ernest Dixon • Mr George Doersch • Dover Museum • Mr C.S. Drake
Mr Joe Drew • Mrs Joyce Elkington • Mr W.H.A. and Mrs Marjorie Fenn
Mr Ray Floyd • Folkestone Local History Society • Mr A.T. Gifford
Mrs Muriel Golding • Mrs Mary Guy • Mr Tom Hackney • Mrs B. Hallum
Mrs Kath Hilson • Mr Fred Hoare • Dr W.E. Holdcroft
R.E Hollingsbee Collection • Imperial War Museum • Mr D.A. Jeffries
Kentish Gazette • Mr John MacGregor • Mr Frank McGovern
MAP/Real Photographs • Margate Library Archives • Mrs Eva Martin
Mr A.J. Moor, *National Geographic Magazine* • Mr W. Murphy
Mr William Nobel • E.R. Oakley/605 Sqn. Assn • Mrs E.M. Owen
Mr John Payne • Major Rex Puttee • Mr Eamon Rooney
Mr John Roots • Royal Artillery Institution • Mr V. Russell
Lt. Cmdr. Sir Peter Scott • S.E. Newspapers/*Kent Messenger*
Mr Harry Shaw • Mrs Irene Shaw • Southern Railway Archives
Mr Alan Stingemore • Mr Alan Taylor • Mr James Timperley
Mr C.J. Tomanciewicz • Mrs Eva Turton
Mr Karl and Mrs Vi Wagner • *The War Illustrated* • Mrs Gwen Whitehead
J. Whorwell & Son • Mr Frank Young
Mr Tony Blake for photographic services
and my wife Pat, for all her patient proof-reading.